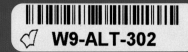
I study nature, so as not to do foolish things, to remain reasonable.

VINCENT VAN GOGH, LETTER TO THEO, OCTOBER 1885

Art is an abstraction: extract from nature while dreaming before it and concentrate more on creating than on the final result.

PAUL GAUGUIN, LETTER TO A FRIEND, SEPTEMBER 1885

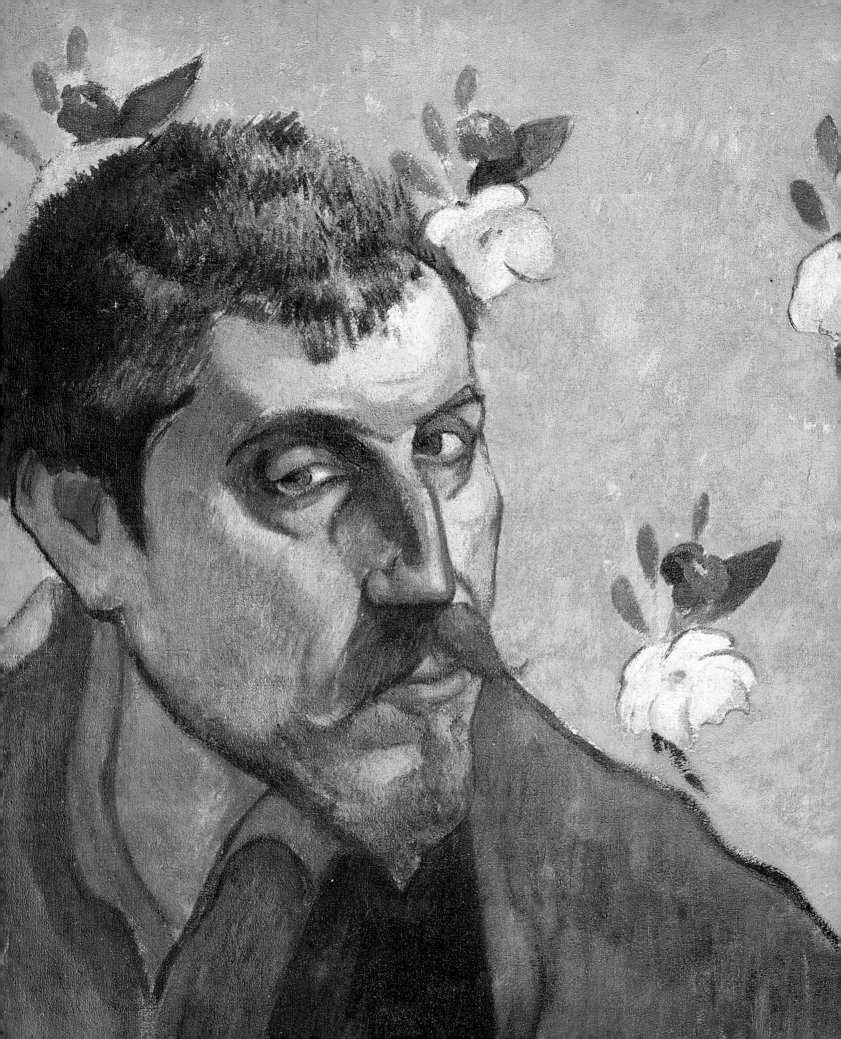

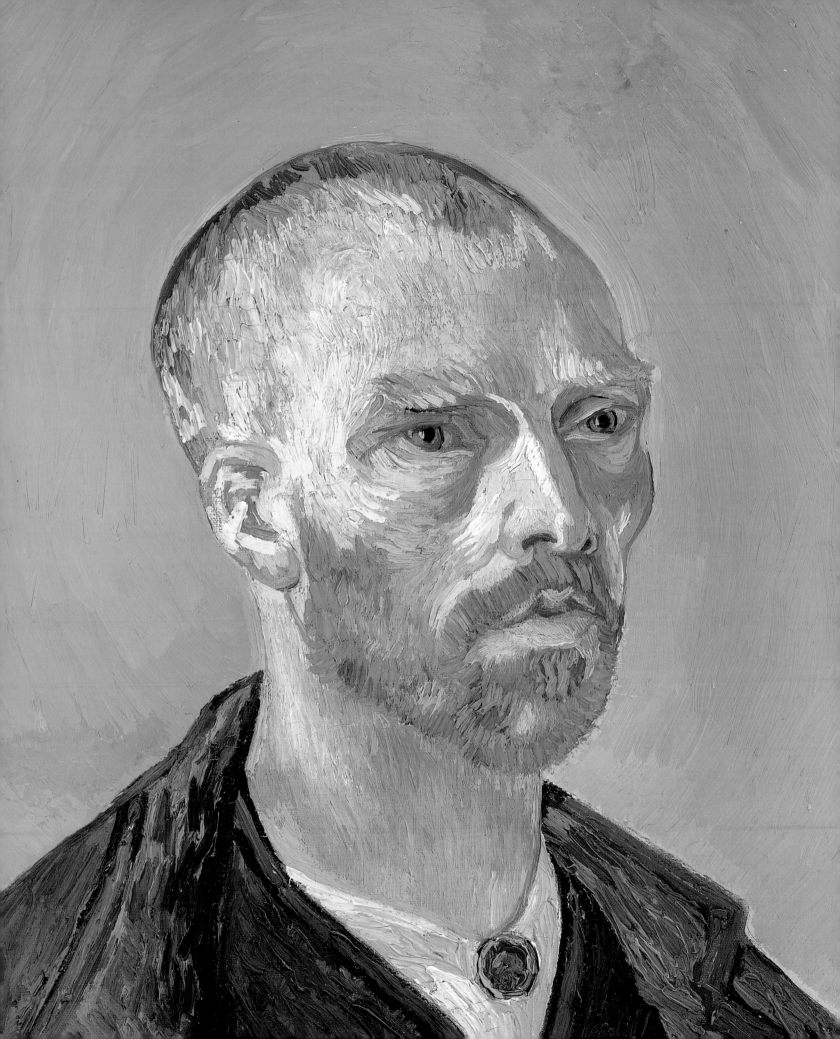

Highlights of the Exhibition

Van Gogh and Gauguin

The Studio of the South

THE ART INSTITUTE OF CHICAGO

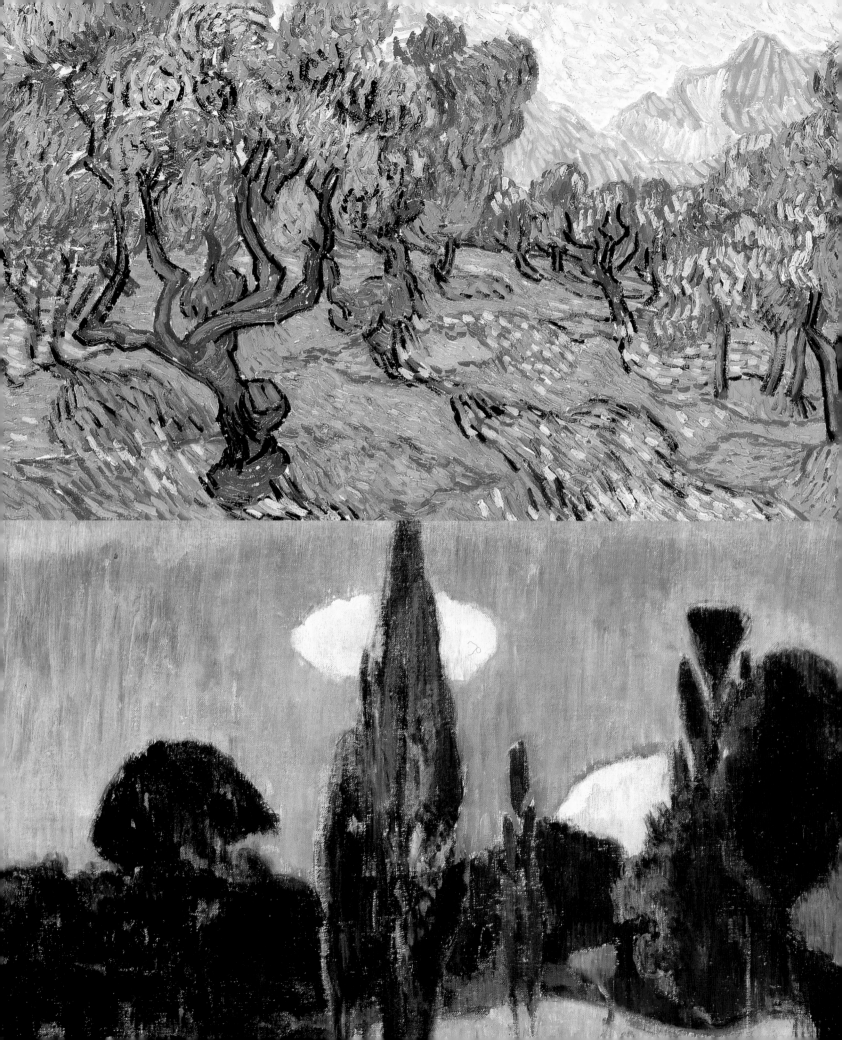

CONTENTS

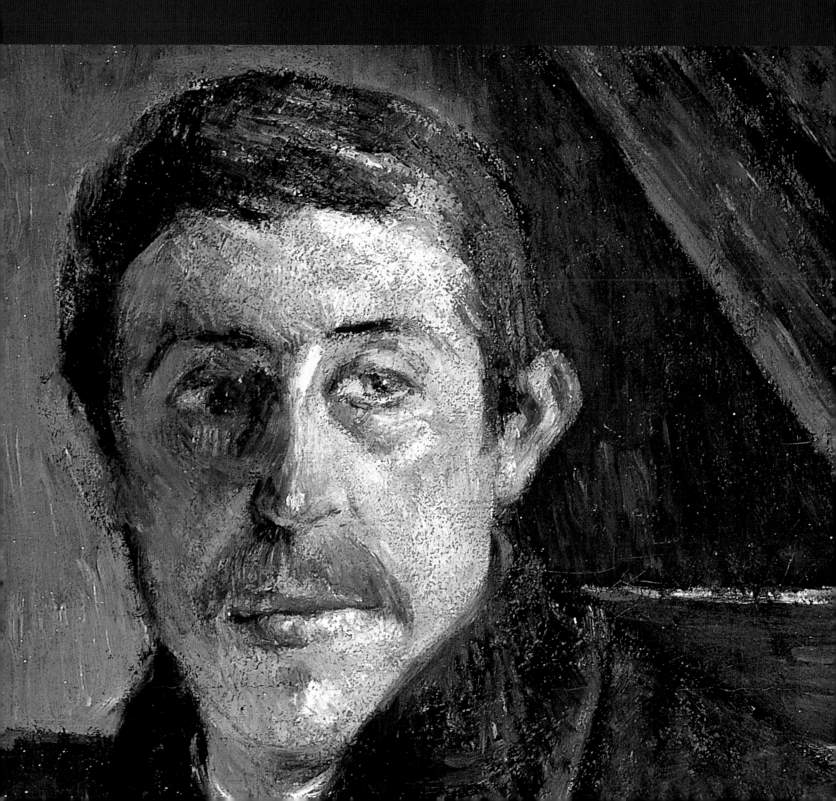

Gauguin
Self-Portrait at the Easel
Fig. 4 (detail)

CHAPTER ONE TWO JOURNEYS

Late in the year 1888, Vincent van Gogh (1853–1890; fig. 1) and Paul Gauguin (1848–1903; see fig. 2) shared a home and studio in Arles, deep in the heart of southern France. Their backgrounds and experiences were profoundly different, but aspects of their personal histories were strikingly similar. Both were self-taught, and having chosen a career in art relatively late in life, both felt an immediate pressure to succeed. Both had suffered professional failures and personal disappointments. Through art they endeavored to better situate themselves in the world, unmask the meaning of their individual existence, and find a visual language that spoke to the truth of their times.

Vincent had a clear sense of the artist's purpose, which he imaged as a journey. The much-traveled Gauguin had yet to similarly define his goals. Before they shared a studio, the two men shared ideas in conversation, letters, and the exchange of paintings. This burgeoning dialogue laid the foundation for an artistic relationship through which van Gogh (who preferred to sign his canvases "Vincent," and we follow him in this hereinafter) hoped to realize a long-cherished dream. Believing that traditional religion failed to address and soothe the

trials of modern life, he regarded art as a potential source of faith and enlightenment. He thought that, if artists assumed a missionary role in society and that if they joined together in a compassionate fraternity, they could bring hope and consolation to a troubled world. Vincent imagined them working and living in a sunny climate, where they could paint outdoors as well as in the studio. The dialogue that Vincent forged with Gauguin gave his dream of the Studio of the South, as he came to call his idea, the weight of reality.

Gauguin's stay with Vincent in Arles was brief. Both were strong-minded and had volatile tempers. The friction that rose between them ultimately resulted in disaster, and they parted ways. But the nine weeks that they lived and worked together, although short and stormy, proved crucial to each man's art, identity, and destiny, and in that sense each carried the Studio of the South with him until the end of his life. For Vincent the Studio of the South remained a special destination, akin to a pilgrimage site that forever changes the pilgrim. And Gauguin bore witness to that transformation: the Studio of the South served for him as a point of departure rather than as a terminus; he left Arles a changed man,

Fig. 3

Vincent van Gogh (Dutch; 1853–1890)
Self-Portrait with Dark Felt Hat at the Easel
Paris, spring 1886

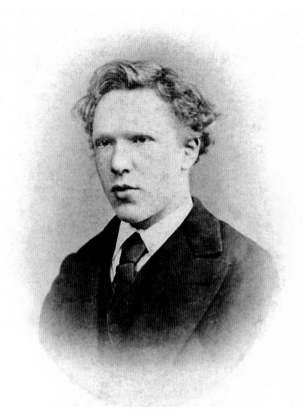

Fig. 1
Photograph of Vincent van Gogh at the age of eighteen.

10

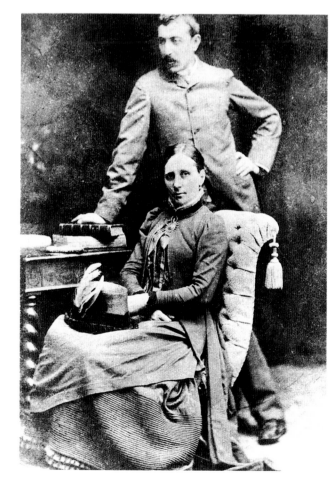

Fig. 2
Photograph of Paul Gauguin and his wife, Mette, Copenhagen, 1885.

redefined by Vincent's vision of him as a peripatetic seeker of a new art for the modern world.

Vincent's personal pilgrimage was shaped by his Dutch cultural heritage and his parents' religious convictions. The Reverend Theodorus Vincent van Gogh and Anna van Gogh-Carbentus followed the tenets of the Groningen School, a modern reform movement within Dutch Calvinism that advocated the imitation of Christ's actions through piety, good works, and self-sacrifice. Vincent held fond memories of his childhood until he turned eleven, when the family sent him away to boarding school. Although a competent student, he suffered a sense of dislocation, and his formal education ended after less than three years. His paternal uncles were successful art dealers, and at sixteen Vincent moved to The Hague to take a position as a junior clerk for the Paris-based international art gallery Goupil et Cie. He was transferred to London in 1873 and then, two years later, to Paris. Vincent rapidly became disenchanted with the commercial art world, which, in his view, fell far short of his idealized belief in the potential for art in contemporary society.

In 1876 Vincent left the gallery to seek a teaching position in England. He was having difficulty coming to terms with the world around him and, always a passionate reader, turned to literature for guidance and illumination. His reading, varied and eclectic, ranged from the

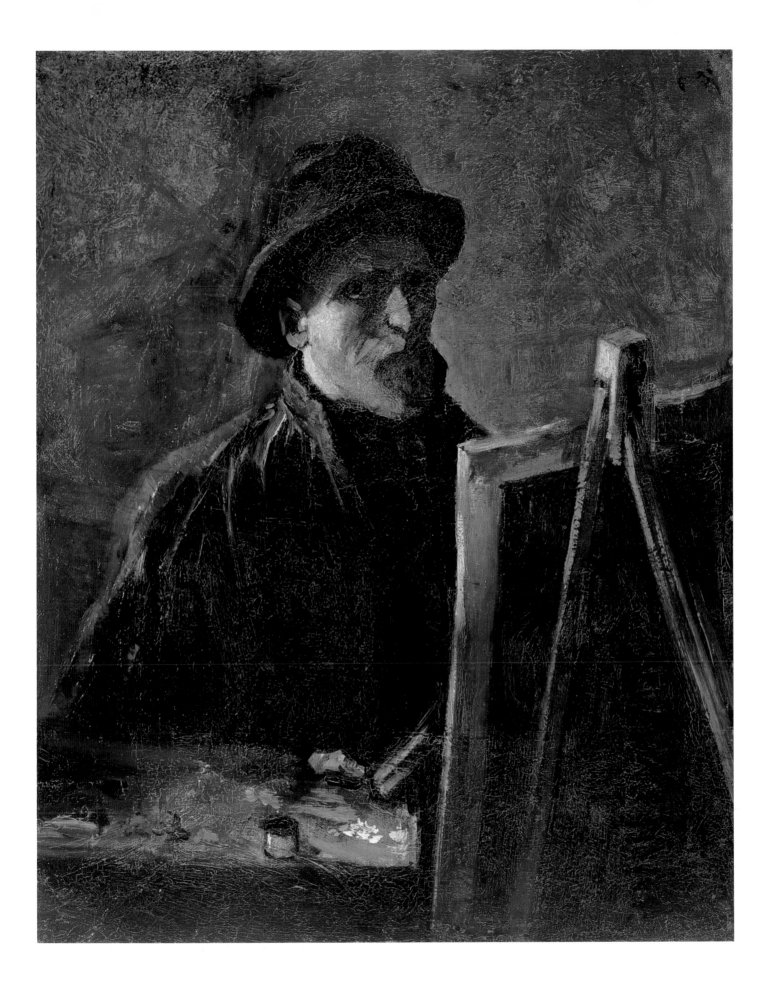

Fig 4
Paul Gauguin (French; 1848–1903)
Self-Portrait at the Easel
Copenhagen, c. 1 May 1885

works of the French Romantic historian Jules Michelet and those of the Scottish social philosopher Thomas Carlyle to the epic novels of Victor Hugo and the Naturalist narratives of George Eliot. Posted at a Methodist school, where he participated in the parish, Vincent decided to enter the clergy. His father insisted that he pursue theological studies in Amsterdam, but the rigorous program daunted him, as did a course he attempted in Brussels to prepare for lay preaching. Early in 1879, Vincent found a position ministering to miners in the bleak Borinage region of southern Belgium. He was determined to live in imitation of Christ, caring for the ill, injured, and poor; but his extreme behavior alarmed the agency that employed him, and he was soon dismissed. Vincent remained in the region on his own for one year, living from hand to mouth. But in 1880 he wrote to his brother Theo, who also had entered the art-gallery business, that he was "homesick for the land of pictures." The fervor that had called him to preaching was now propelling him into the arts.

Paul Gauguin's youth was also marked by displacement and shifting career paths. His mother, Aline Marie Chazal, was the daughter of the pioneering feminist Flora Tristan, who claimed descent from a prominent Spanish family residing in Peru. Gauguin's father, Clovis, editor of a radical Parisian newspaper, uprooted his wife and children in 1849

and took them to Lima. Clovis Gauguin died en route, and Aline arrived in the Peruvian capital a widow with a daughter and an infant son, Paul. They found a home with Aline's grand-uncle Don Pio de Tristán y Moscoso, a rich and influential figure in the government. Aline and her children remained in Peru until 1854, when impending political upheaval prompted her departure.

Back in France, Gauguin's family experienced an exile of a different sort. Without resources, Aline moved to the city of Orléans, where her late husband's father lived, and enrolled young Paul in a local day school. In 1859 he entered a progressive academy, and two years later, his mother left him in Orléans to find work as a dressmaker in Paris. There, she became acquainted with Gustave Arosa, a wealthy businessman of Spanish descent. Gauguin joined her in the French capital one year later to prepare for entrance examinations to the Naval Academy. But within two years, he returned to Orléans, and in 1865 enlisted as an officer's candidate in the merchant marines. Traveling around the world, Gauguin did not return to Paris until 1871, four years after his mother's death.

At the age of twenty-three, Gauguin had five years' experience as a sailor and a considerable inheritance from his paternal grandfather, but he faced an uncertain future. Arosa took him under his wing, securing him a job as a stock-exchange agent. In 1873 Gauguin married

a Danish woman, Mette Gad (see fig. 2), whom he met through Arosa. He also began to paint, perhaps influenced by Arosa's fine collection of modern art, which included works by Jean Baptiste Camille Corot, Eugène Delacroix, and Camille Pissarro, among others. A naturally skilled amateur, Gauguin exhibited a landscape in the 1876 Salon, the annual, state-sponsored venue for art. But his independent point of view made him question conventional standards, and he began to collect the art of Pissarro, who introduced him to some of the most advanced artists in Paris. In 1879 Gauguin accepted an invitation to present his work at the fourth Impressionist exhibition.

Gauguin's avocation gave him a sense of purpose and identity that he had never found in own profession, and he increasingly channeled his passion and energy into his art. Although he exhibited works in the final three Impressionist exhibitions, he failed to secure either a dealer or a patron. An economic crisis in 1881 had depressed the art market. It also affected his work as a stock agent, and Gauguin found himself in financial difficulty. To relieve some of the strain, Mette took their growing family to Copenhagen to live with her parents. Having lost his job, Gauguin joined them in 1884. These struggles only strengthened his conviction that art, rather than the conventions of bourgeois life, would define his destiny.

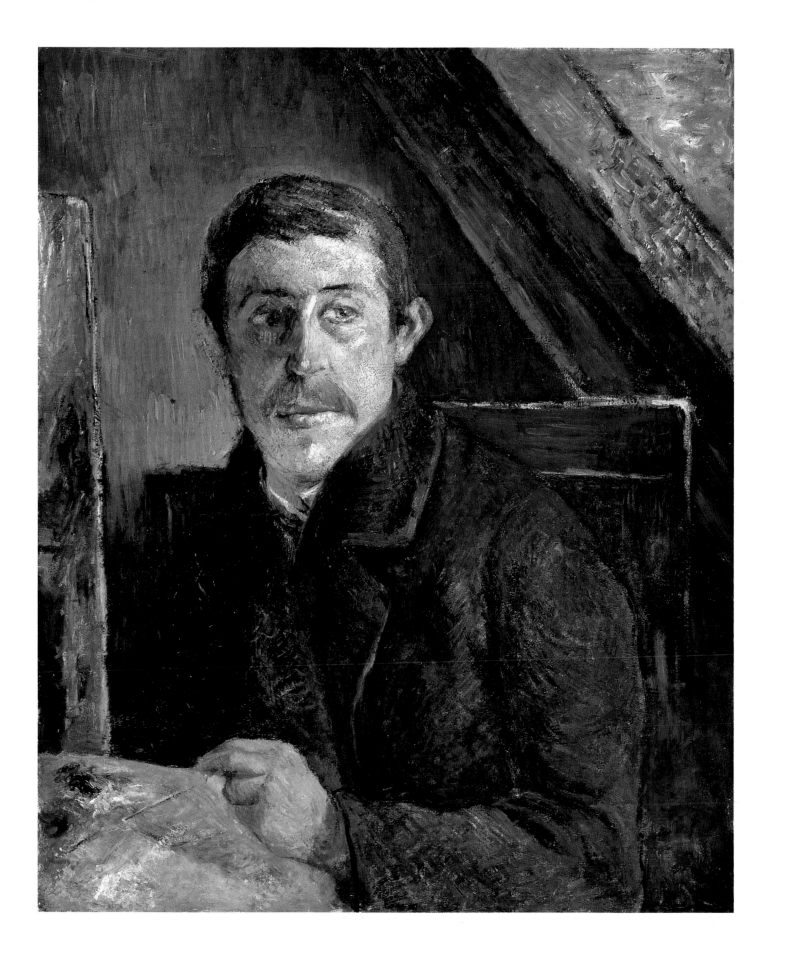

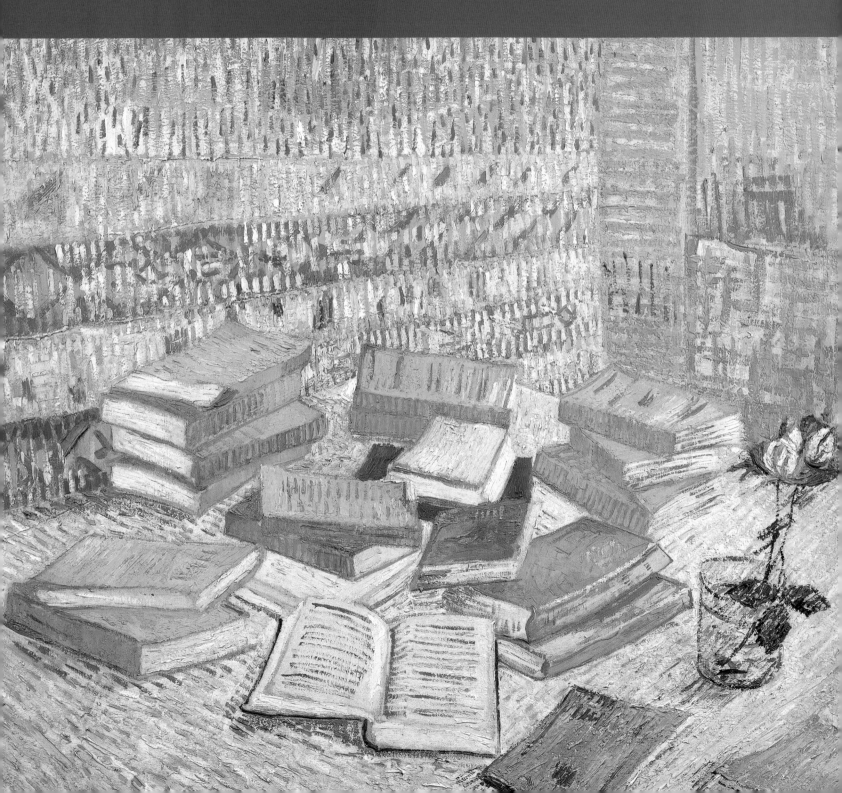

CROSSING PATHS

Vincent's decision to devote himself to art set him on a circuitous journey. In the spring of 1881, he took up residence with his parents, who had moved to Etten, in the province of North Brabant, while he studied drawing manuals and copied reproductions of the rural subjects of the French painter Jean François Millet. At the end of the year, he moved to The Hague and found a mentor in his cousin Anton Mauve, a prominent painter. Their association was brief. Art had now replaced Vincent's traditional religious beliefs, and his expectations of other artists were so high that he inevitably faced disappointment. As he sharpened his skills, he also constructed an independent identity for himself that led him to sign his works "Vincent," a gesture corresponding to a growing feeling that he confessed to his brother: "Essentially I am *not a 'van Gogh.'*" Discouraged by the conventional art community in The Hague, in 1883 Vincent relocated to Drenthe, a picturesque region of vast moors in the northern Netherlands. After three months there, he rejoined his parents, who had by now settled in the village of Nuenen.

In Nuenen Vincent sketched field workers and painted his signal tribute to the Dutch peasantry, *The Potato Eaters* (1885; Amsterdam, Van Gogh Museum). The death of his father in March 1885 added a new dimension to his sense of mission. The relationship between them had been turbulent for years, and in his attempt to follow his father's footsteps into a clerical career, Vincent had waged a long battle with doubt about traditional religious practice. A still life featuring a modern novel, an open Bible, and an extinguished candle that he painted several months after his father's death charts Vincent's search to find an alternative belief system for modern society and for himself. In *Still Life with Bible and Zola's "Joie de vivre"* (fig. 5), Vincent's deliberate selection of Naturalist writer Émile Zola's darkly philosophical novel imbues the composition with a deep, personal meaning. Vincent's still life identifies contemporary literature as a new gospel for modern society, supplanting the old truths of the Bible preached by his father.

Late in 1885, Vincent moved to Antwerp, and by the early months of

15

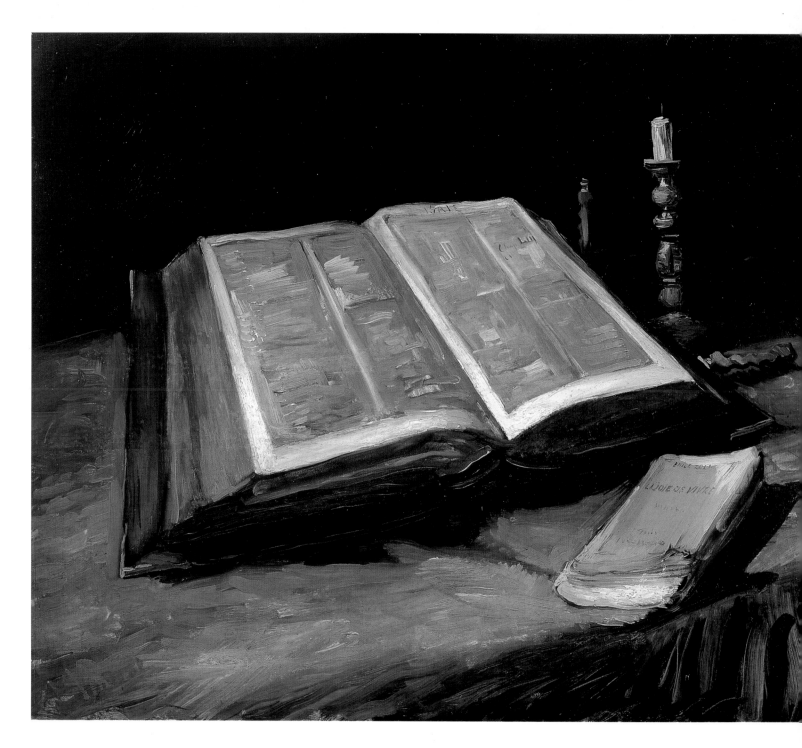

Fig. 5
Van Gogh
Still Life with Bible and Zola's "Joie de vivre"
Nuenen, October 1885

1886, he felt strong enough in his independent identity as a painter to seek company of other artists. His brother Theo was working in the Paris branch of Boussod, Valadon et Cie (formerly Goupil's). Vincent expressed his avid desire to join him there, convinced that he and his sibling could set up a studio in Paris that would provide artists with a creative refuge from the tradition-bound standards of the academy and demands of the marketplace. Despite Theo's request that he wait until summer, Vincent arrived in Paris in March, determined to launch his career.

Gauguin returned to France from Denmark in June 1885. He left his family in hopes of establishing himself as a professional painter, planning to have them join him after he attained a sufficient financial security. To make ends meet, he took odd jobs. The extensive critical attention given to the eighth (and last) Impressionist exhibition raised his expectations for a career breakthrough, but the works he exhibited there—nineteen paintings and a wood relief—were completely overshadowed by a breathtaking series of nudes by Edgar Degas and the arresting canvases of the "Neo-Impressionists," led by Georges Seurat. Their innovative approach to color and optics is exemplified by Seurat's epic pointillist composition *Sunday on La Grande Jatte—1884* (1884–86; The Art Institute of Chicago). Gauguin could have opted to join this vanguard, as had his mentor, Pissarro, but he dismissed the style as "petit point." Mainstream critics in turn dismissed him as merely a new follower of classic Impressionism.

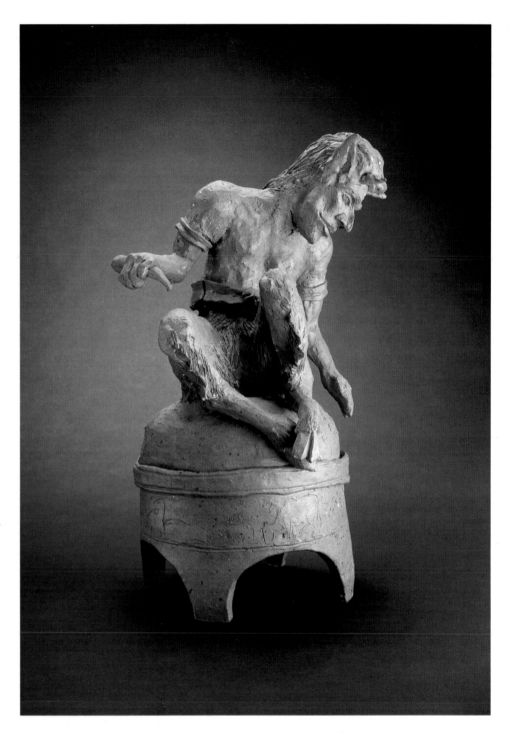

Fig. 6
Gauguin
The Faun
Paris, winter 1886

Fig. 7
Gauguin
Breton Shepherdess
Pont-Aven, summer 1886

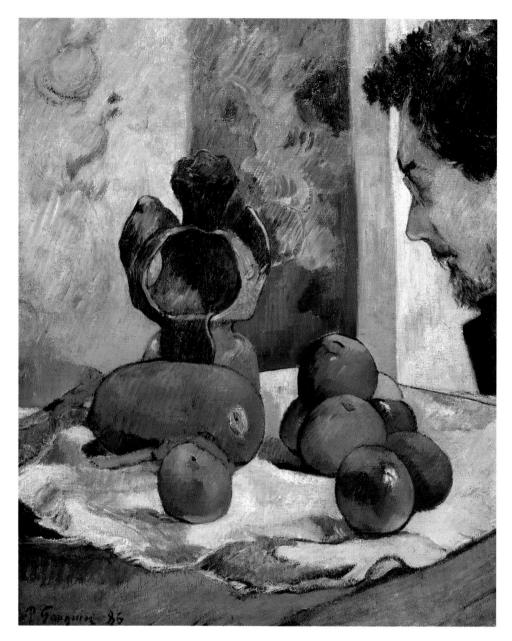

Later in June, Gauguin began to produce ceramic sculpture for the studio of Ernest Chaplet. The intimate contact of shaping the clay offered him a freedom of expression he had not yet found in painting. One of his first works in the medium, a three-dimensional figure of a faun (fig. 6), constitutes a traditional personification of the carnality of human desire. By giving the classical creature—half man, half beast—facial features modeled on his own, Gauguin revealed the conflicts he felt in transforming himself from a bourgeois, with a mundane job and marital and parental responsibilities, to a bohemian artist, fueled by creative energy and in touch with his primal urges.

At the end of July, Gauguin left Paris to paint in Brittany. He settled in the town of Pont-Aven, where a substantial artists' colony had existed since the mid-1860s. Contemporary guidebooks characterize Brittany as remote and savage, home to an ancient culture that had survived, relatively unchanged, into the present. But at the time, Gauguin had little interest in the "myth of place" and even less in the artists' community. His impetus to move was, in large part, financial. Gauguin claimed that he wanted to "make art in a backwater," where the cost of living was modest. In the course of his fourteen-week stay, he explored various directions, employing bold contours, simplified planes, and unconventional arrangements of figures to create a stylis-

tic primitivism for subjects that he regarded as equally primitive. In works such as *Breton Shepherdess* (fig. 7), he achieved a new, decorative quality.

Upon his return to Paris in October, Gauguin resumed his experiments in sculpture, but he remained unsure as to

how to pursue in painting the direction he was exploring in his ceramics. He dramatized his dilemma in *Still Life with Profile of Charles Laval* (fig. 8), in which a table is positioned in the corner of a room, topped with a crumpled cloth strewn with fruit, recalling the still-life

19

arrangements of Paul Cézanne, whose work Gauguin admired and had collected in his stockbroker years. The tranquil mood is disturbed by two intrusions: a face in profile and one of Gauguin's freely modeled ceramic forms. The face is that of Charles Laval, a young painter Gauguin had met in Brittany; Gauguin presented him here as a stand-in for the viewer. Looking quizzical, he seems to be trying to make sense of what is before him.

In April 1887, seeking financial opportunities, Gauguin sailed with Laval to Panama. They found jobs related to the construction of the canal, but the working conditions were terrible and Laval contracted yellow fever. Within a few weeks, Gauguin was laid off, and the two men relocated to the French colony of Martinique, where they shared a small hut. Gauguin regarded Martinique as a tropical paradise, and he painted the colorful vegetation and local populace with vibrancy and vigor (see fig. 9). But he too fell ill with fever and dysentery; by mid-November, having run short of funds, he was forced to return to Paris.

Vincent arrived in Paris intent on self-transformation. After years of poverty and physical neglect, he was determined to improve his appearance, and Theo soon reported that Vincent was so changed that his mother would not recognize him. He had purchased new clothes, trimmed his beard, and visited a dentist, striving for a fresh external iden-

tity that reflected his resolve "to produce and to be something." He enrolled for several months of study at the Atelier Libre (Free Studio) run by the painter Fernand Cormon, where he met other aspiring artists, including Émile Bernard and Henri de Toulouse-Lautrec. Vincent soon abandoned the atelier to work alone, but he maintained relationships with his fellow artists and others he met through them, regularly visiting studios and receiving visits in turn at the apartment that he and his brother shared in Montmartre.

Making the rounds of exhibitions of contemporary art gave Vincent ideas for new directions for his own painting. He had read about avant-garde art before he came to Paris; when he saw examples first-hand, he began to absorb the influences of Impressionism and Neo-Impressionism simultaneously. Vincent's early palette reflects the dark and somber tradition of his homeland (see fig. 3), but now he began a rigorous regime of chromatic experimentation, painting floral still lifes to develop his ability to "render *intense color*." He was also inspired by the example of Provençal painter Adolphe Monticelli, whose richly colored, thickly painted still lifes Theo had begun to collect and sell. By the summer, Vincent had mastered a loose and gestural handling, gradually shifting from dark tonalities to bolder, complementary colors. Always fascinated by the proximity of

town and country in the Netherlands, Vincent enjoyed the environs of Montmartre, on the city's northern edge, where pockets of rural life still nestled in the hilly landscape. Painting outdoors, he made studies of the cottages and their humble gardens and, with his some of his new painter friends, traveled to the suburb of Asnières, where he rendered scenes of outdoor life in sun-drenched color (see fig. 10).

The stylistic innovations of Neo-Impressionism prompted Vincent to use a pointillist brush stroke in a self-portrait painted in the spring of 1887 (fig. 11). But his emphatically expressive touch and the decorative effect of his complementary tonalities ran counter to the cool rationalism of the scientific approach of Seurat and his circle. Vincent felt free to experiment, merging the convictions he had brought to Paris with the new modes of expression he developed there. His initial admiration for the rural imagery of Millet was rekindled by a large retrospective exhibition in May 1887. Previously, he had emulated Millet's still life of worker's clogs in monochrome; for a new version, *A Pair of Boots* (fig. 12), he used contrasting colors of orange and blue. That summer he made studies of the cut heads of dry sunflowers (see fig. 13). The rustic flower had special meaning in Dutch culture. In the emblematic tradition to which Vincent was exposed in his youth, it was a metaphor of devotion:

Fig. 9
Gauguin
Conversation (Tropics)
Martinique, summer 1887

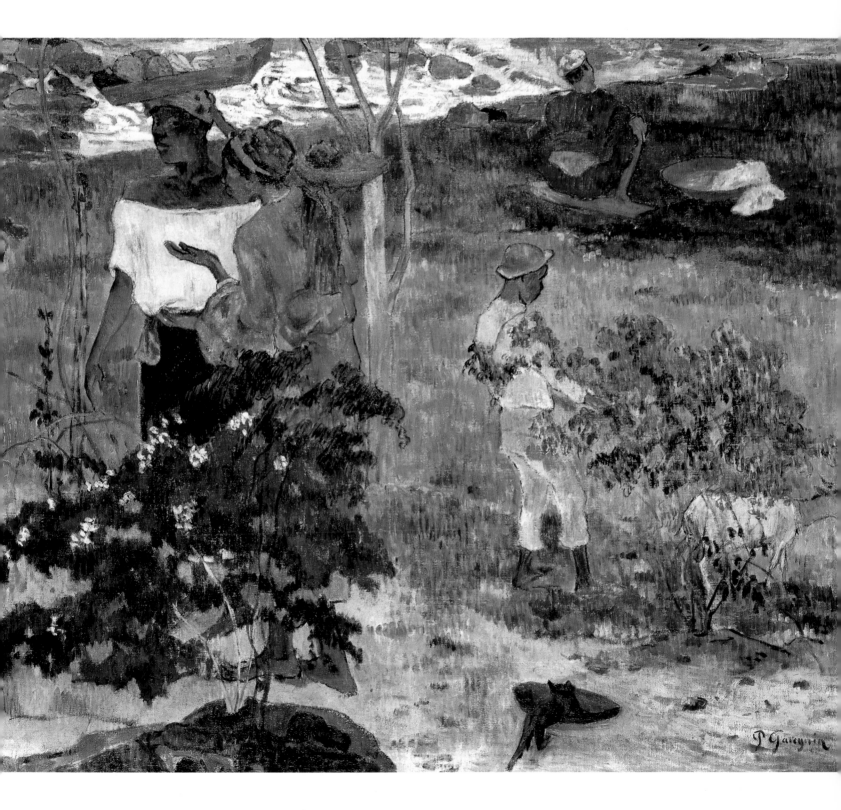

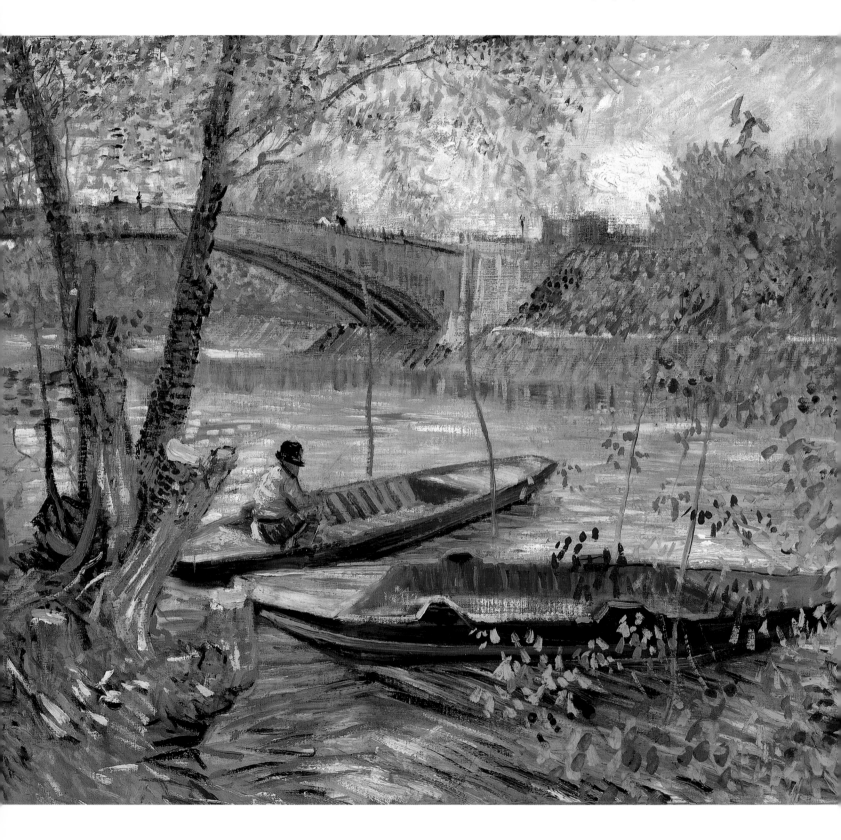

Fig. 11
Van Gogh
Self-Portrait
Paris, spring 1887

Fig. 12
Van Gogh
A Pair of Boots
Paris, summer 1887

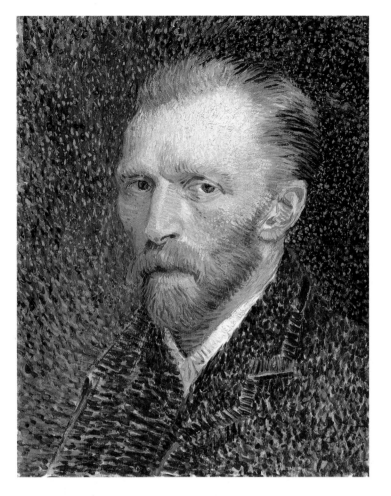

just as the giant bloom follows the sun, the pious were urged to turn to Christ, the light of the world.

Vincent and Theo met Gauguin in November, shortly after the latter's return to Paris. Both brothers were impressed with the painter and his works from Martinique. In them Vincent saw a deep humanism, expressive of the delicate balance between life's joys and sorrows that he found the works of Rembrandt van Rijn and Millet but did not discern in those of his contemporaries. Theo decided to take some of Gauguin's canvases on consignment, and he acquired *Les Négresses (Among the Mangoes)* (1887; Amsterdam, Van Gogh Museum) for himself. Vincent suggested that he and Gauguin trade pictures; Gauguin agreed and exchanged a Martinique canvas (1887; Amsterdam, Van Gogh Museum) for two studies of cut sunflowers.

Learning the details of Gauguin's life, Vincent was impressed by the sacrifices he had made for his art, thinking of him as he thought of himself, "an adventurer [not] by choice but by fate," and a "stranger" even to his family and homeland. The meeting with Gauguin inspired Vincent to reprise elements of his *Still Life with Bible and Zola's "Joie de vivre"* in

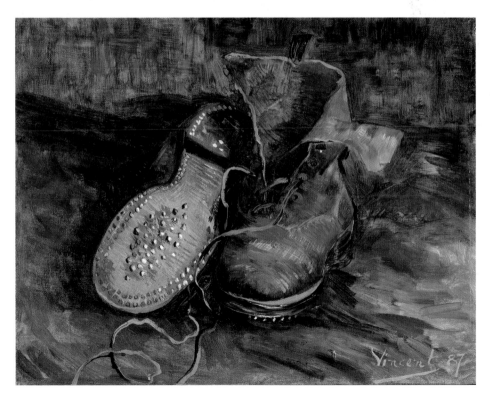

Fig. 13
Van Gogh
Two Sunflowers
Paris, summer 1887

Fig. 14
Van Gogh
Parisian Novels
Paris, late 1887

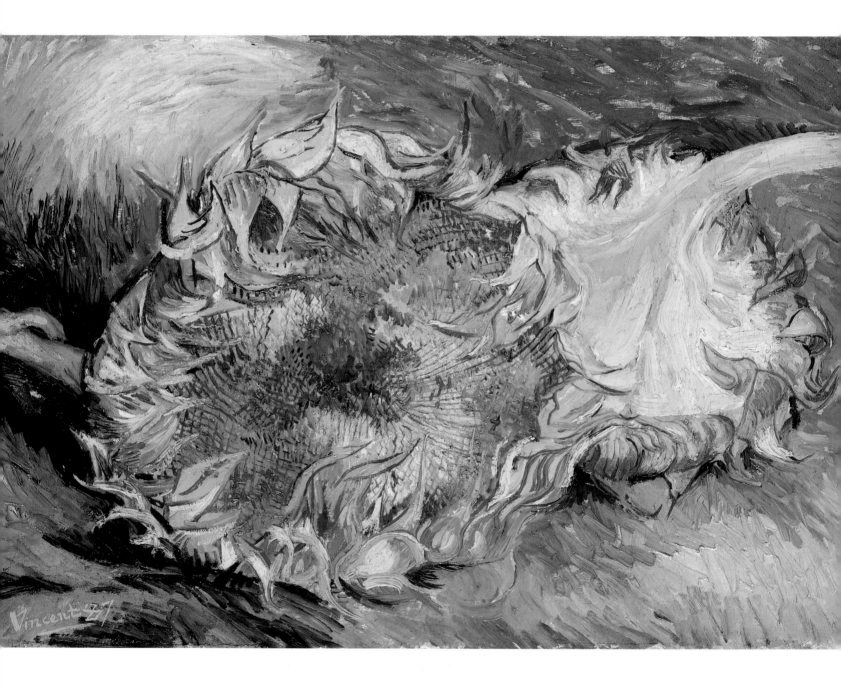

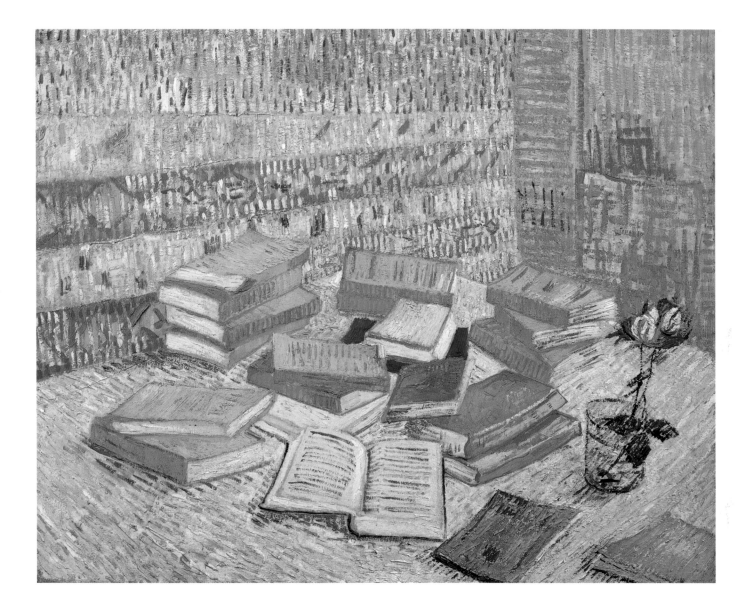

the canvas *Parisian Novels* (fig. 14). The books' bright jackets are set against the tabletop's variegated whites and the richly patterned wall covering. Although the lively palette reveals that Vincent had transformed his formal language, the motif of the Naturalist novel continued to symbolize for Vincent the primacy of creating a new gospel for modern society. Vincent's encounter with Gauguin and his work gave him hope that what he admired in contemporary literature and in the art of the past could be achieved in the art of the future.

In January 1888, after a scant three months in the capital, Gauguin returned to Brittany. Vincent had long talked about leaving the city, but now he was motivated to do so. Winter that year in Paris was early and brutally harsh, and Vincent longed for sun and a gentler climate. The stimulation of urban life and the sophisticated art community had drained him. He was weary of the sectarian and competitive environment of the Paris art world; as before in The Hague, the corrosive atmosphere frustrated him. On 19 February, he boarded a train for Arles in the south of France. Writing to their sister Wil, Theo explained that Vincent longed to "get sunshine into his pictures," but he also realized that his brother had had "more than enough of Paris."

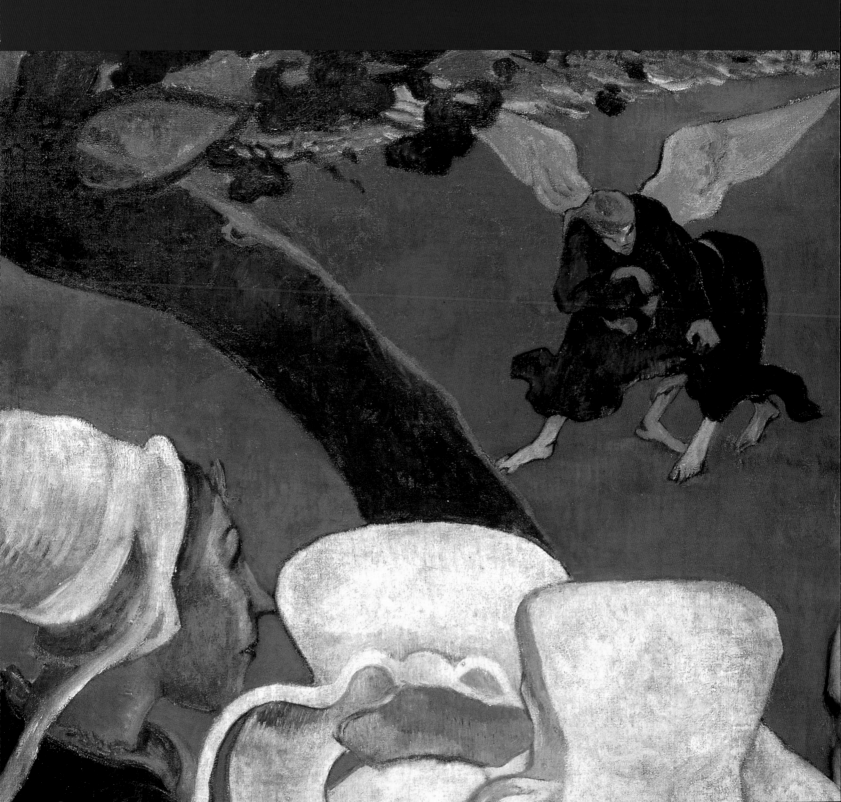

Gauguin
Vision of the Sermon
Fig. 21 (detail)

DIFFERENT DESTINATIONS

When Gauguin first traveled to Pont-Aven in 1886, his motivations were mostly practical. In January 1888, fueled by conversations with Vincent, he embarked on his second sojourn with a desire to transform himself as well as his circumstances. Just before his departure, he cautioned his wife in a letter to remember that he was a man possessed of "two natures, the Indian and the tender-hearted"—the savage and the civilized. He forged this atavistic identity by refashioning his mother's heritage, supplanting a Spanish colonial line proud of its racial "purity" with an imagined indigenous Peruvian ancestry that linked him to primitive and remote origins. He planned to remain in Brittany for at least seven months to absorb the spirit of the region and its populace. Thus, he allied himself with the mythic character of this remote area, regarding it as the appropriate setting for self-transformation, a place where he could release the primal force of his creative power.

Like Gauguin, Vincent departed Paris in pursuit of much more than a change of scenery. He too sought to achieve a new artistic vision. He had many reasons for choosing Provence as his destination. He had read contemporary novels about life in southern France which convinced him that the region offered an environment where a volatile and creative soul such as himself could flourish. As noted, he had grown up in a culture that associated the sun with spiritual renewal; just as the strengthening sun regenerated the earth in the cycle of seasons, Vincent hoped to restore his physical and psychic health in a warmer clime.

Although Vincent had never before been to Arles, in his mind the town held the promise of a pilgrim's destination; there, with renewed body and soul, he imagined an art that would reflect his new circumstances. Not only did he believe that in Provence he would find calm and realize his artistic potential, but he trusted that he would not be isolated, for he was paving the way for like-minded artists to join him. In the months he spent had with Theo in Paris, Vincent continued to harbor the idea of a community of artists who, by combining forces, would be able to work and live, sustaining one another spiritually and materially, and eventually sharing the profits derived from sales. While

27

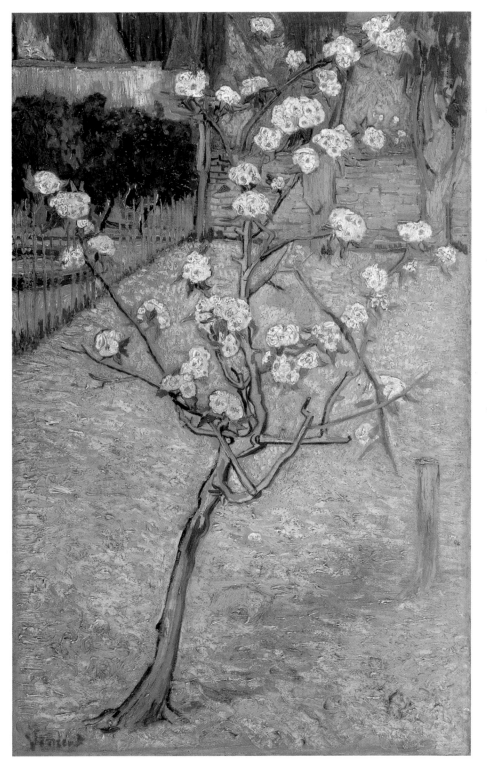

Fig. 15
Van Gogh
Pear Tree in Blossom
Arles, April 1888

Vincent was aware of several European models for this concept, his imagination was captured by Asia. Like many artists of his generation, Vincent collected Japanese prints. His interest in them was primarily formal; he admired their brilliant color, simplified forms, and unconventional compositions. But Vincent also idealized Japan and imagined that life there resembled the delicate world the prints portray. Through this lens, the Japanese appeared to Vincent as innocent, purposeful, and responsive to nature, leading him to position their artistic community in counterpoint to that of Europe. Unlike the factionalized environment he had observed in Paris, Vincent assumed that the way in which Japanese artists lived was harmonious and caring; they resembled a community of brothers, laboring, as he put it, "close to nature like simple workmen." Just as he believed that Naturalist literature provided a modern alternative to the old truths of the Bible, Vincent was convinced that Arles could become the western equivalent of Japan, where artists could work together, sharing their purpose in life in an atmosphere of mutual support and tranquility.

Vincent arrived in Arles on 20 February to find the town blanketed in snow. It was the coldest winter the South had experienced in decades, but Vincent took it in stride, comparing the frozen,

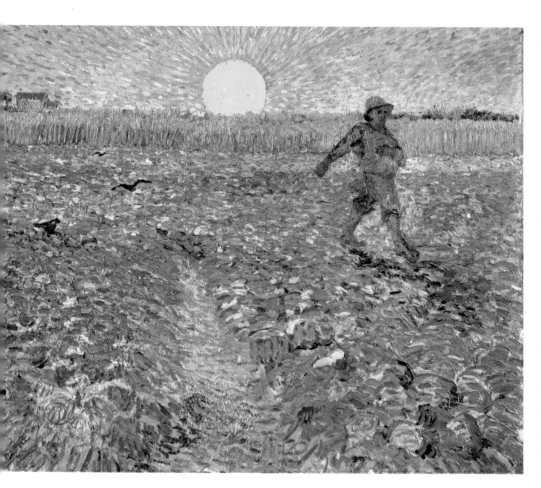

Fig. 16
Van Gogh
The Sower
Arles, mid-June 1888

canvas after canvas, and as his work piled up, the proprietor of his hotel added a storage surcharge to his bills for food and lodging.

On 1 May, Vincent signed a five-month lease for the right-hand portion of a building on the sunny side of place Lamartine. He called the building the Yellow House, because of the butter-colored hue of its painted exterior; inside, the white-washed walls reflected the warm, natural light. He planned to use the ground-floor rooms as kitchen, studio, and storage space; the upper floor could provide his bedroom and a room for a guest. Vincent lacked the funds to furnish the Yellow House, so he remained at a hotel. But the lease raised his expectations: it was the first step toward achieving his dream of a brotherhood of artists in the South.

Shortly after he rented the Yellow House, Vincent wrote to his brother, "I could quite well share the new studio with someone. Perhaps Gauguin will come south?" He couched his suggestion in an offhand manner, noting that housekeeping and cooking would be cheaper for two than for one. Over the coming weeks, Vincent transformed a sketchy plan for a potential roommate in his unfurnished house into the possibility of establishing a permanent studio in the South, with Gauguin at its helm. Through their steady correspondence,

flat countryside, with the lilac-tinted Alpilles in the distance, to "the winter landscapes the Japanese have painted." Arles had a venerable history. Founded as a Greek colony in the sixth century B.C.E., it became a major outpost of the Roman Empire known as the "Rome of Gaul." During the later Middle Ages, the city enjoyed a second golden era, with troubadour poetry being its most enduring legacy. But, after centuries of decline, Arles had devolved into a sleepy provincial town dependent upon local agriculture: the olives, grains, and grapes grown on the Crau, a region of stony plains to the east and south. The popular express train from Paris to Marseilles did not even stop at Arles; there were few tourists

and no active artists' colony. But all this mattered little to Vincent. In fact Arles's lack of a distinctive character made it easier for him to project his expectations onto the place.

Shortly after his arrival, Vincent began to paint, finding his subjects where the city blended into the countryside. When the local orchards blossomed in the early spring, he undertook a projected series chronicling the seasons. He saw an "astonishing gaiety" in the flowering fruit trees, and he linked the subject with Japan. In works such as *Pear Tree in Blossom* (fig. 15), he adopted the high vantage point, abrupt rhythms, and spiky contours that typify Japanese interpretations of similar motifs. He completed

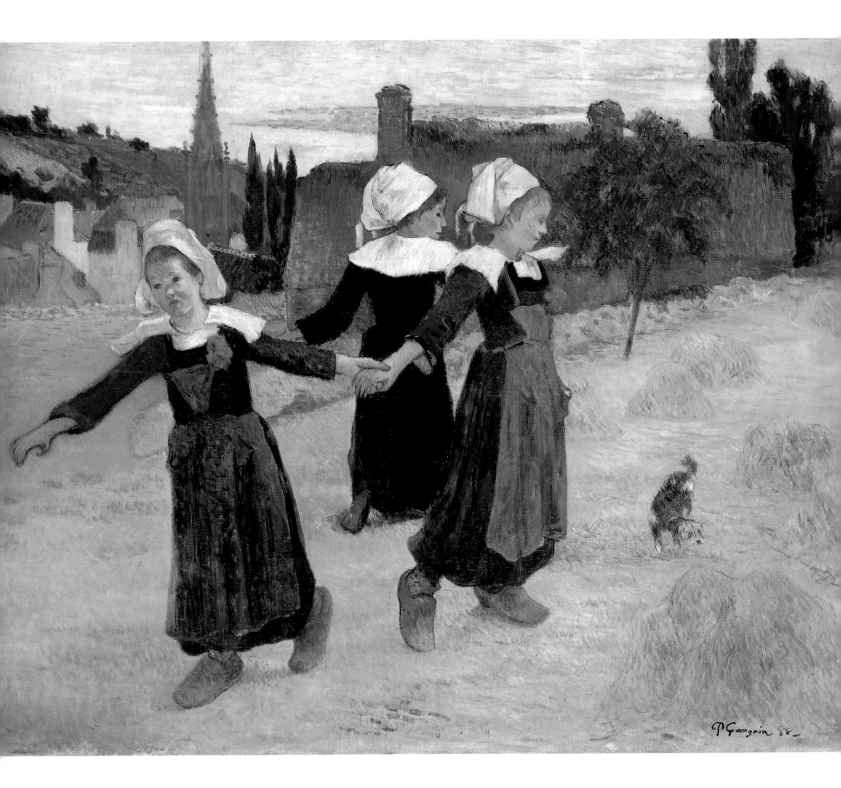

Fig. 17
Gauguin
Breton Girls Dancing
Pont-Aven, June 1888

Vincent knew that Gauguin was facing difficulties in Brittany. The fierce winds and constant rain prevented him from working outside, and the climate had undermined his health. He had exhausted the money he had made on recent sales to pay down his debts. Early in June, Vincent wrote to Gauguin, expressing his regret that such distance separated them and sharing his hopes that, in the near future, several painters could gather in the same locale for one "campaign." Shortly after, Theo sent fifty francs to Gauguin with a letter proposing that the artist join his brother in Arles. Gauguin saw merit in the idea of artists sharing a household, employing Vincent's metaphor by comparing such a brotherhood to sailors singing together "to sustain each other and bolster each other's spirit." Still, he fixed no plans to head south, and now Vincent waited anxiously for Gauguin to make the next move.

As spring passed into summer, Vincent observed the changes in the fields and turned from images of promised bounty to those of active cultivation. Recalling a favorite work by Millet, he portrayed the lone figure of a sower under the blazing Provençal sun (fig. 16). In his choice of palette—contrasts of violet and yellow—Vincent continued the chromatic explorations he had begun in Paris. But the emblematic image of the sower, long a symbol of rebirth, proclaimed his purpose in Arles: he cast himself in the role of painter-as-missionary, sowing ideas that he hoped would germinate under the southern sun.

Around the same time, still in Pont-Aven, Gauguin began work on a new composition, which he described as a "Breton gavotte danced by three girls amid the hay" (fig. 17). Rather than a celebration of rustic grace, Gauguin painted figures with blank expressions and incongruent poses. Far more compelling were his formal choices: the lively play of the white coifs against the contrasting dark garments and yellow ground. Despite the work's narrative title, the gestures in *Breton Girls Dancing* appear random and enigmatic, resulting in an image that is intriguing in its strangeness.

Throughout the summer, Gauguin remained vague about his plans, and Vincent's anxiety escalated. The letters and sketches they exchanged established a growing dialogue, but they also bear witness to Vincent's influence on Gauguin's continuing formulation of a new self-image and the elements of a new art. Vincent feared that Gauguin would want to remain where he was to pursue these paths. Encouraged by Vincent, Émile Bernard joined Gauguin in Pont-Aven. The young artist brought with him the letters and sketches Vincent had sent

him. Bernard's age and inexperience gave Vincent a relative air of confidence, so that he often wrote to him in a more personally revealing manner than he dared take with Gauguin. Bernard's presence triangulated the dialogue, as Gauguin read Bernard's letters from Vincent and often included messages of his own in the younger painter's responses.

Gauguin's continuing financial debt postponed his departure for Arles. As an alternative, Vincent proposed that he join Gauguin and Bernard in Pont-Aven, but Gauguin's silence on the matter disconcerted him. As Vincent waited for Gauguin to make up his mind, he swung back and forth between buoyant optimism and dark despair, thinking that the reality of his plan was at hand, only to have his expectations dashed by delay. To alleviate his fears, Vincent channeled his anxious energy into a new project, which he described in a letter to Bernard as a half-dozen pictures of sunflowers (see fig. 18) for the studio: "a decoration in which the raw or broken chrome yellows will blaze forth on various backgrounds." He envisioned the series as a kind of surrogate for Gauguin's company, writing, "How much I would like to be able to spend these days in Pont-Aven; however, I find consolation in contemplating the sunflowers." But in the context of Vincent's cultural heritage,

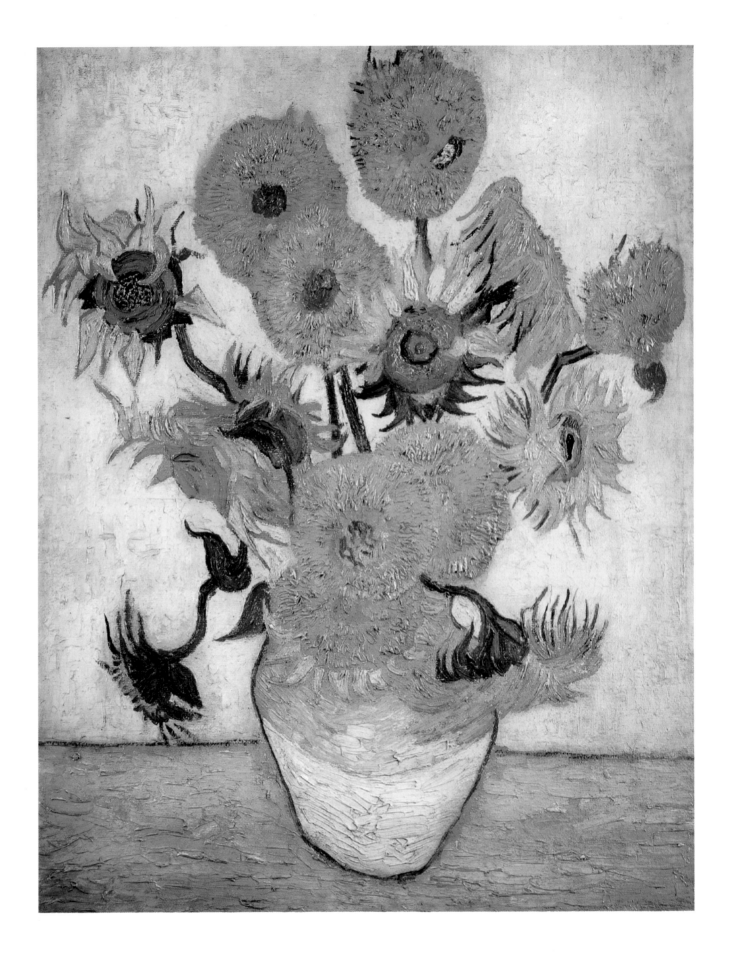

Fig. 18
Van Gogh
*Sunflowers (*reprise of *Sunflowers* painted late
August 1888*)*
Arles, c. 1 December 1888

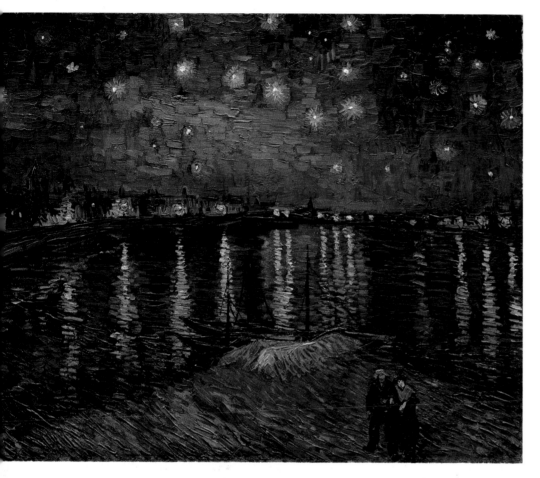

Fig. 19
Van Gogh
The Starry Night over the Rhone
Arles, 28 September 1888

painted in a rapturous state, which he found exhausting but addictive. As the summer ended, he worked at the same furious pace on scenes of Arles, *The Starry Night over the Rhone* (fig. 19) and a portrait of the Yellow House (fig. 20). His approach reflected both his exhilaration and anxiety; in his quest to formulate an art of calming consolation, he produced expressive paintings that are among his most admired works.

Late in September, Gauguin informed Vincent that he had completed *Vision of the Sermon* (fig. 21), a painting he had begun shortly after Bernard's arrival. In it Gauguin attempted both a new subject and a new style: To achieve something truly different—the nature of religious experience made clear for a modern audience—he had to paint differently. News of this success with a religious subject enforced Vincent's sense of inferiority to Gauguin. His own attempts that summer to depict Christ in the garden of Gethsemane had failed. Unable to hire models to pose for him, he was forced to depart from his regular practice of always painting from nature. Twice he scraped off the surface of the canvas and then abandoned the subject. Gauguin's *Vision*

the selection of the sunflower was as emblematic as it was decorative. His first exchange with Gauguin had involved two sunflower images. An enduring symbol of devotion to a higher force, the sunflower became an iconic expression of Vincent's admiration for Gauguin. Now anticipating Gauguin's arrival, he longed to demonstrate what he had learned living in the South.

Vincent worked with speed on his canvases, racing to complete them before the cut flowers wilted. He began by establishing the composition with a contour sketch, which he reinforced with painted lines. He then blocked in the background and primary forms in thin layers of paint, but as the image took form, he freely worked the surface in brilliant color and heavy impasto. Vincent did not hesitate to use color directly from the tube, and he combined colors so rapidly on his palette that veins of separate pigments run through individual brush strokes. Vincent

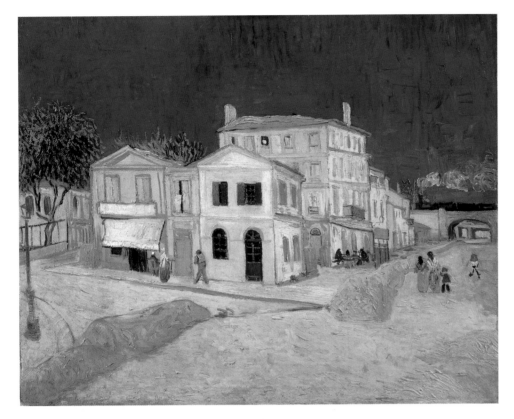

Fig. 20
Van Gogh
The Yellow House
Arles, 28 September 1888

34

of the Sermon features a group of Breton women, in their pitch-black dresses and luminous yellow-white bonnets, who pray with their priest, while Jacob and the Angel wrestle in the background. When Gauguin sent a description and a sketch of the work to Vincent, he explained that the landscape and the struggling pair existed only in the minds of the parishioners after they heard the sermon. To separate the zones of reality and the imagination, Gauguin bifurcated his canvas with a rugged tree branch. The blood-red background, ritualized gestures, and decorative pattern of the women's headgear create an aura of unreality that alludes to an internal spiritual state rather than the observance of external appearance. In *Vision of the Sermon*, Gauguin shed the last remnants of conventional restraints on his art and moved out of the world of natural representation into the realm of ideas and the spirit.

In mid-September, Vincent moved into the Yellow House alone. To compensate for the absence of companions, he had requested that Bernard and Gauguin paint each other and send the portraits to him. Vincent had already completed his own portrait for the ensemble, appearing gaunt with close-clipped hair (fig. 22). The austere self-image was inspired by a Japanese *bonze*, or simple follower of Buddha. His portrait defined his expectations for the residents of the Yellow House: he would be the devoted monk, learning from Gauguin, who would serve as the secular abbot of their brotherhood.

Vincent assumed that Gauguin and Bernard would do the portraits straight away, and when he learned that they did not, he became indignant and questioned their seriousness of purpose: "And such fellows call themselves portraitists; living so long together and not making up their minds to pose for one another, and they will separate without having painted each other's portrait!" To assuage him, Gauguin responded that he had not yet captured Bernard's likeness, but he was studying him to paint from memory. But instead of a portrait of their friend, Gauguin described a self-portrait in the guise of the noble but persecuted protagonist of Victor Hugo's novel *Les Misérables* that he planned to send to Vincent (fig. 23). The novel was one of Vincent's life-long touchstones, and the prospect of viewing Gauguin's image with, as the latter described it, "the face of an outlaw, ill-clad and powerful like Jean Valjean" raised his expectations for further empathetic exchange. When Vincent actually received the work, he was disturbed by Gauguin's grim visage and shrewd gaze. The dark and melancholic mood of this self-presentation broke Vincent's cardinal rule: that painting should offer consolation. He assured himself that Gauguin would paint a very different self-portrait after some time in Arles. He did not have to wait much longer. On 23 October, five months after Theo had extended his brother's initial invitation, Gauguin arrived in Arles.

Fig. 21
Gauguin
Vision of the Sermon
Pont-Aven, mid-August–mid-September 1888

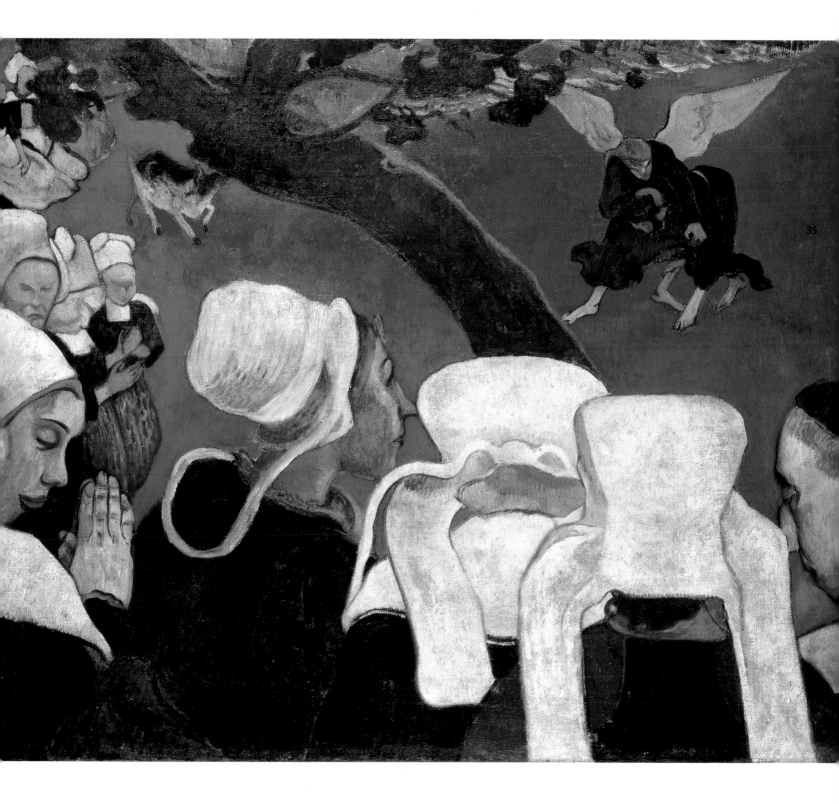

35

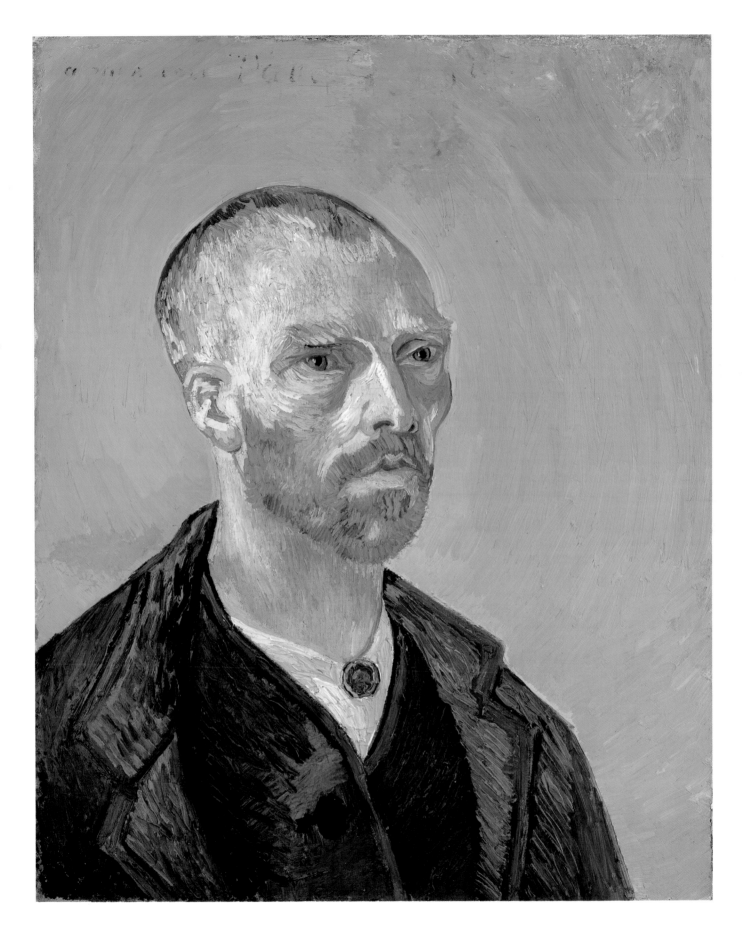

Fig. 22
Van Gogh
Self-Portrait Dedicated to Paul Gauguin (Bonze)
Arles, c. 16 September 1888

Fig. 23
Gauguin
Self-Portrait Dedicated to Vincent van Gogh
 (Les Misérables)
Pont-Aven, late September 1888

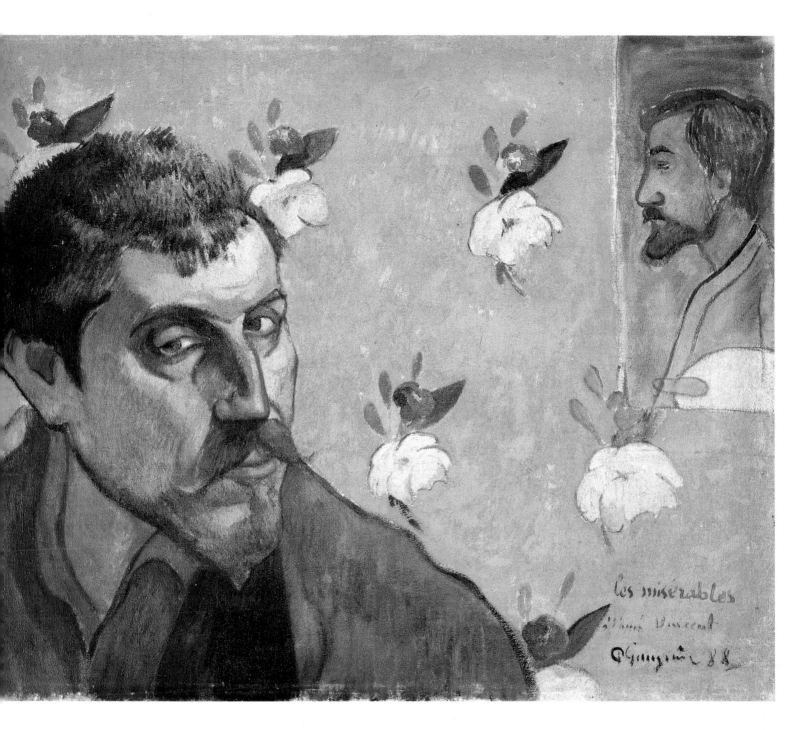

Van Gogh
Allée des Tombeaux (Les Alyscamps)
Fig. 24 (detail)

STUDIO OF THE SOUTH

In anticipation of Gauguin's arrival in Arles, Vincent transformed the Yellow House into what he described as a "painter's paradise." He installed gaslights in the first-floor studio and hung his sunflower canvases in the newly furnished guest room. Vincent's ideas reflected more than his desire to ensure Gauguin's comfort and gain his approval. He envisioned the house as a symbolic site on a sacred route, the portal to the Studio of the South, where he and Gauguin would receive others dedicated to forging a new path in modern art. To this end, Vincent purchased twelve simple, rush-bottomed chairs and an armchair to accommodate what he hoped would be an association of like-minded artists, with Gauguin as its leader. The sunflowers reinforced his message; like the flower's diurnal movements, he and his fellow disciples would pay homage to Gauguin's higher artistic authority.

When Vincent and Gauguin met on 23 October, after eight months of correspondence, each was surprised at the other's appearance. Vincent found Gauguin in far better health than he had expected, while Gauguin was struck by Vincent's emotional agitation. To calm his host, Gauguin shared colorful tales of his past adventures, confirming Vincent's

belief that he had found the right partner for his demanding endeavor. Gauguin enjoyed his friend's eager attentions, but, with his independent nature, he likely found it difficult to live and work with Vincent in such close proximity. The house was small, and Vincent expected them to spend all their waking hours together. The only entrance to Gauguin's sleeping quarters, hung with a number of Vincent's paintings, was through his host's bedroom, where the walls displayed several more of his works (see fig. 44).

Almost immediately after Gauguin's arrival, the two artists set out with their easels to paint. This marked a departure from Gauguin's usual practice; he preferred to take time to acquire a sense of place, to immerse himself in local customs and make drawings as a prelude to any serious work. On their initial excursion, the two artists headed to one of Vincent's favorite locations on the plains of the Crau. In the second week, they moved to the ancient cemetery known as Les Alyscamps (Elysian Fields). Vincent had previously avoided this site, but now he was determined to convince Gauguin of Arles's picturesque attractions. Founded deep in the city's pagan past, Les Alyscamps also served as a celebrated burial ground during the Middle Ages.

39

Fig. 24
Van Gogh
Allée des Tombeaux (Les Alyscamps)
Arles, c. 29 October 1888

Fig. 25
Gauguin
*Les Alyscamps (The Three Graces
at the Temple of Venus)*
Arles, c. 29 October 1888

40

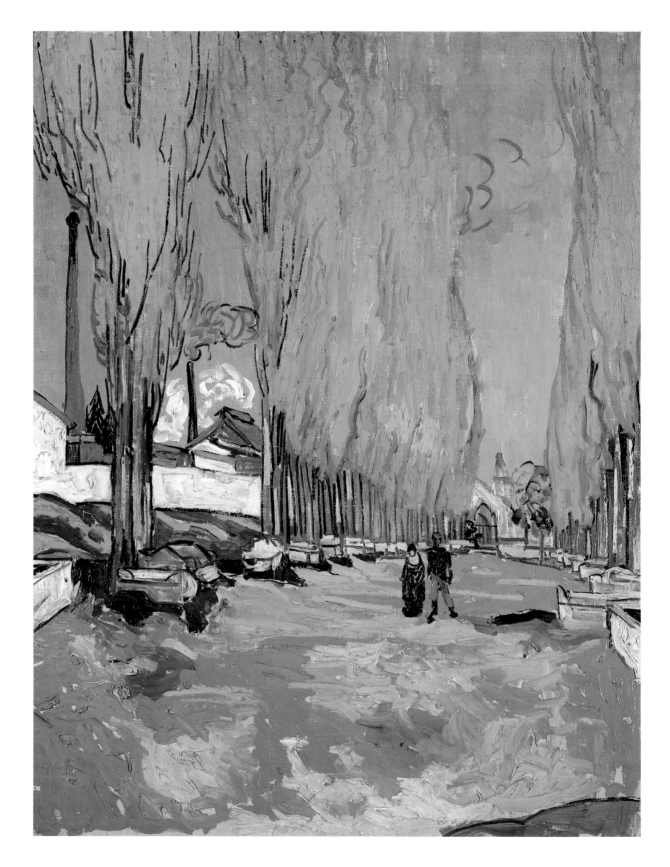

Fig. 26
Van Gogh
The Arlésienne (Madame Ginoux)
Arles, c. 4 November 1888

By the late nineteenth century, it was somewhat neglected, but a well-established pictorial tradition used the ancient cemetery as an ideal backdrop in romantic representations of Arlésiennes in their traditional dress. With their classical profiles and noble bearing, the beautiful local women seemed to embody the region's Roman heritage. Vincent seemed to realize that the lure of the Arlésiennes would be an important part of his campaign to keep his companion fascinated with Arles.

With their easels close together, Vincent and Gauguin each depicted a slightly different perspective of the Allée des Tombeaux, the poplar-lined lane bordered by ancient sarcophagi (figs. 24–25). But more telling were the differences in how they conceived their subjects. On the path, Vincent placed two "lovers" (a male and female couple being a favorite symbol for him of ideal companionship), an Arlésienne in her striking garments, accompanied by a soldier, or Zouave, in his distinctive regimental uniform. But theirs was not a long-term relationship, for the Zouaves were not permanent residents of Arles; they were billeted in town while en route to other destinations. The composition includes another note of modernity: the smokestacks of a nearby factory. In his painting, Gauguin depicted three Arlésiennes, mute and devoid of gesture. Unlike

Fig. 27
Gauguin
Madame Ginoux (study for *Night Café*)
Arles, c. 4 November 1888

strokes to create a shimmering effect. In the course of four days, Vincent completed three of four views of the site, while Gauguin undertook two, which he planned to finish in the studio.

Early in November, Marie Ginoux, proprietress of the Café de la Gare on place Lamartine, sat for a portrait in the Yellow House. In the hour-long session, Vincent completed a painting (fig. 26) and Gauguin worked on a large drawing (fig. 27). Madame Ginoux, wearing the distinctive Arlésienne costume, sat in the armchair in the studio, and Vincent positioned his easel several feet behind and to the right of Gauguin. He could observe Gauguin's deliberate method, but he proceeded in his own manner, working quickly in response to what he saw. The closer perspective gave Gauguin a direct view of Madame Ginoux, and she returned his analytic gaze with frank confidence, an exchange Vincent saw but could not join.

Gauguin incorporated his study into the painting *Night Café* (fig. 28), positioning the denizens of Arles's nightlife behind the monumental form of Madame Ginoux, whose expression he transformed into a mask of sly complicity. Vincent had painted his own version of the subject that summer (New Haven, Yale University Art Gallery), but while he had evoked a mood of haunting alienation, Gauguin captured the salacious

Vincent, he screened out all indications of modern industry and gave no indication of a narrative. The timelessness of the scene is underscored by the ancient domed structure in the background and the title he assigned the work: *The Three Graces at the Temple of Venus*. In execution

as well as composition, Gauguin presented an alternative to the Naturalist bent of his companion's picture. While Vincent painted fast, slashing on the pigment in rich, broad strokes, Gauguin worked the surface with overlapping layers of varied color, using small diagonal

Fig. 28
Gauguin
Night Café
Arles, 4–12 November 1888

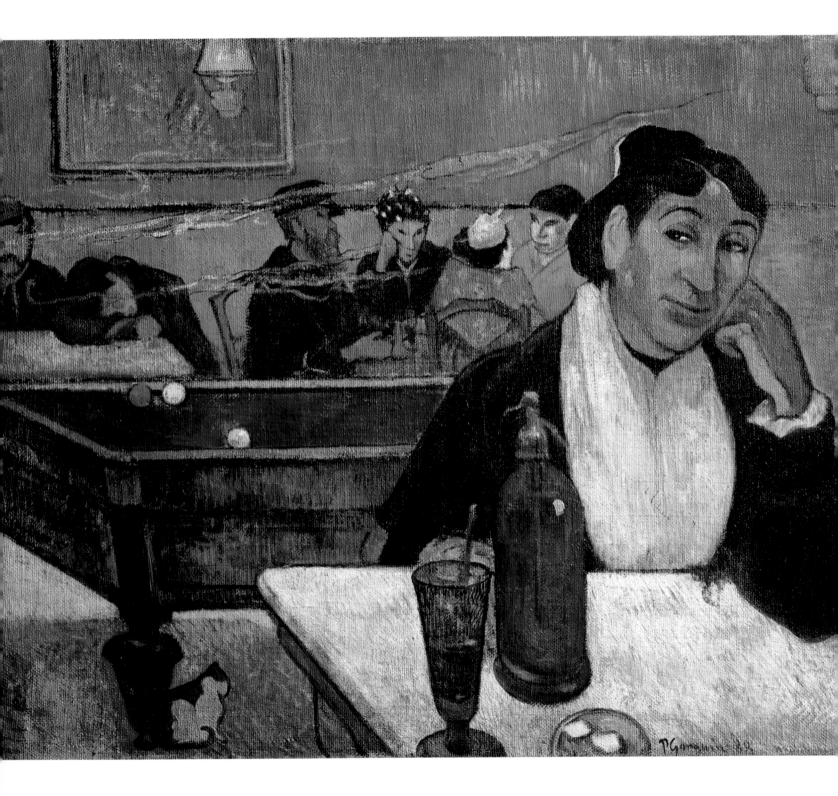

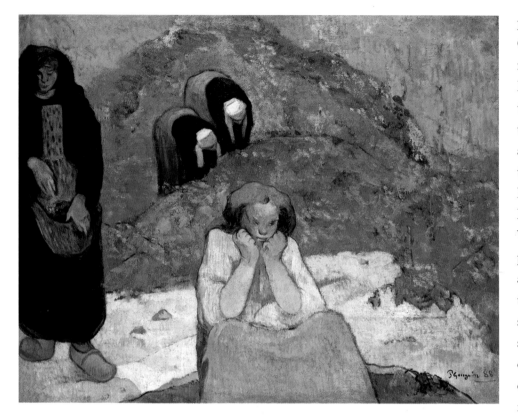

points of difference between Vincent and Gauguin. Unlike his friend, Vincent had never felt comfortable working only from his imagination or *de tête* (literally, from the head). Now, because of his admiration for Gauguin's evocative vision, and also because inclement weather forced them both indoors, Vincent tried, with limited success, to rely on his memory. But working *de tête* did not suit him. Vincent had come to understand that painting quickly before a natural motif allowed him to render reality subjectively, but it also liberated him from his self-consciousness through total immersion in activity. He and Gauguin had debated these issues in their lengthy correspondence—painting fast versus reflectively, nature versus the imagination, open-air versus studio work, the responsive oil study (*étude*) versus the deliberate composition (*tableau*)—and now they became sites of challenge in the pair's current efforts.

In a letter to Theo, Vincent hinted at discomfort with Gauguin's influence on his art: "Gauguin, in spite of himself and in spite of me, has more or less indicated to me that it is time for me to vary my style a little bit." Gauguin spoke more directly of the difficulties of their situation, writing to Bernard that Arles fell short of his expectations and that in general, with regards to painting, he and Vincent did not see "eye to eye."

45

aspect of Ginoux's café. The close and unhealthy atmosphere in Gauguin's painting brings to life a page from a Naturalist novel. Although Vincent admired the picture, perhaps because of its naturalistic treatment of a subject he had already addressed, Gauguin was dissatisfied with the result. He found the finished canvas labored and "the coarse local color" not to his taste.

Living and working with Vincent, Gauguin felt the impact of his companion's deeply held enthusiasms. Some he already shared, such as an admiration for the art of the Romantic painter Delacroix, but others, most notably Vincent's lifetime passion for literature, were clearly a revelation to him. *Human Miseries* (*Grape Harvest* or *Poverty*) (fig. 29) suggests that Gauguin listened to his friend and carefully observed what he was doing. Choosing a theme—sorrow—that Vincent had explored from his earliest years as an artist, Gauguin covered the surface with uncharacteristically thick paints. But, unlike Vincent, he conveyed a desperate mood through poetic discontinuity and a sense of ambiguity.

The issues of narrative painting and technical process were not the only

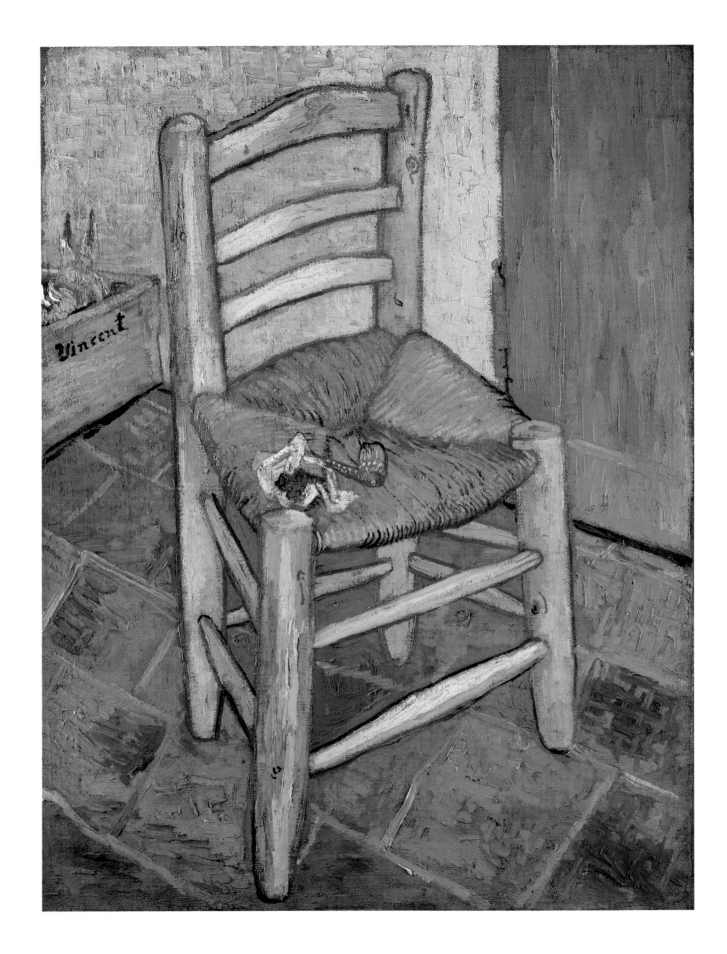

Fig. 30
Van Gogh
Van Gogh's Chair
Arles, c. 20 November 1888

Fig. 31
Van Gogh
Gauguin's Chair
Arles, c. 20 November 1888

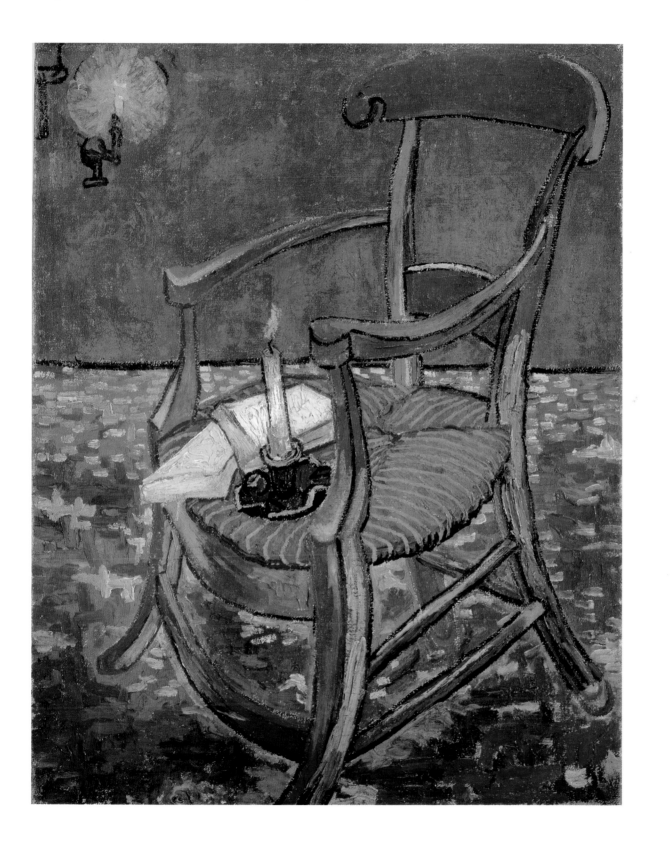

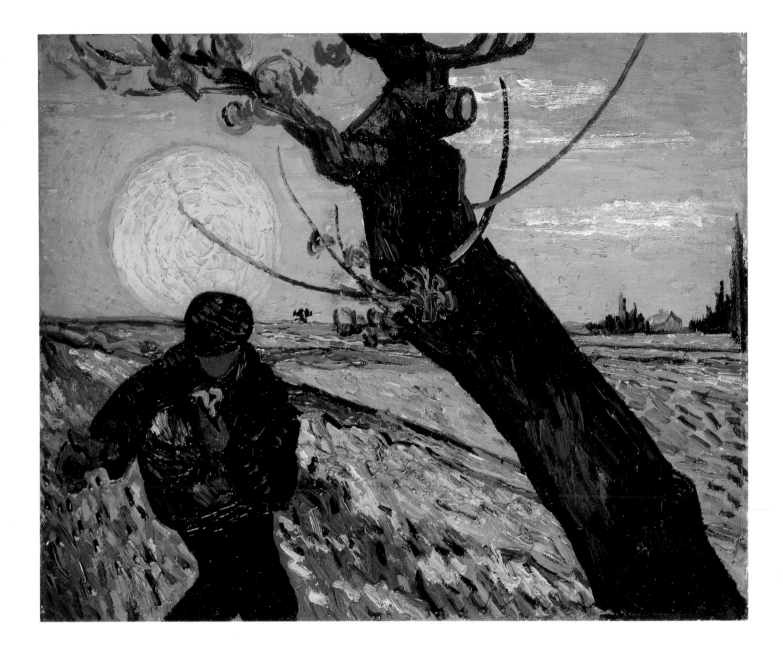

Although Vincent cited tolerance of difference as the hallmark of a committed friendship, he had a history of stubbornness in the face of opposition. In his all-or-nothing approach to relationships, he anticipated shared convictions and accepted no deviation from them. To criticize his painting was to criticize him; negative opinions were tantamount to physical assault. And, as the weather grew colder, forcing Vincent and

Gauguin to work inside, the Yellow House grew more confining. Had they been in Paris, even sharing quarters, Gauguin could have sought relief from his host's constant company. But in Arles Vincent was a continual presence; it is likely that he attempted to keep the debates going from the moment Gauguin awoke until he retired for the night.

Vincent addressed their differences in a pair of images featuring a solitary chair,

each of which represents one of the painters. For his own surrogate, he selected one of the dozen rush-bottomed chairs, creating a totally spare image to which he later added a pipe and tobacco on the seat and a crate of onions in the background (fig. 30). For Gauguin he chose the elegant armchair reserved for the head of the establishment (fig. 31); the composition includes two novels and a burning candle resting on the seat.

Fig. 32
Van Gogh
The Sower
Arles, c. 25 November 1888

Vincent conceived the images as chromatic complements but iconographic opposites. He depicted his own chair in daylight, with yellow as the dominant tonality. (Both men now regarded yellow as Vincent's signature color.) On the other hand, Gauguin's chair, with rich tones of red and green, represents the more complex realm of nocturnal mystery. The combination of a burning candle and books, the latter being long-favored elements in Vincent's still lifes, suggest the leadership position he assigned to his colleague. But in this, Vincent asserted his own persona more than that of Gauguin. His remarkable decision to paint the chairs without their occupants did not detract from their message of identity; they portray his vision of himself and his companion in the roles he intended them both to play.

The friction in their lives caused by differences of opinion was exacerbated by news from Paris. Theo's representation of Gauguin's recent work from Brittany had attracted new critical interest and led to several sales. Vincent wrote to his brother voicing his pleasure at Gauguin's rising success, but as Gauguin's fortunes waxed, Vincent's confidence waned. Around this time, the two had begun to reformulate Vincent's vision of the Studio of the South. Vincent imagined young painters traveling to exotic equatorial locales, such as the Dutch colonial possessions in the East and West Indies, with Arles serving as "a way station between Africa, the Tropics, and the people of the North." He inferred that such an adventure was not for him, and while he allowed that Gauguin might want return for a while to Martinique, it was clear that his aim was to involve Gauguin more deeply in his dream of an association of painters based in Arles. This strategy proved effective in engaging his companion's imagination, but it also strengthened Gauguin's conviction that his time in Arles was meant to end. Believing that his recent successes in Paris marked a turning point in his career, he spoke of saving enough money over one year's time to prepare for his departure. As Gauguin's own idea of a mission in the tropics took form, Vincent's malaise grew, and he confided his hopes to Theo that, if Gauguin did succeed on this new path, friendship and business would help them maintain their connection.

Vincent reasserted his own vision by reprising a subject of the previous summer, *The Sower* (fig. 32), his image for the seminal work of the Studio of the South. He attributed his inspiration to a stunning sunset he and Gauguin had observed during one of their habitual evening walks. In his reprise of the theme, Vincent rose to the challenge of Gauguin's more considered approach to design, using the thrusting diagonal of a tree trunk to divide the space into broad, schematic planes, just as Gauguin had done in *Vision of the Sermon* (fig. 21). Vincent maintained a complementary palette of yellows and blues but imbued them with greater chromatic richness and expression. By moving the figure to the foreground, he made it more monumental. Backlit and cast in shadow, the powerful sower embodies the meaning of his essential gesture: the outstretched hand releasing seeds to the fertile ground.

At the end of November, the bitter north wind and freezing rain confined the painters to working indoors. Vincent was in the midst of an ambitious undertaking. He had long believed that portraiture was the premier subject of painting, and he had convinced his friend the postman Joseph Roulin, and his family, to sit for him. By December Gauguin was working on a portrait as well, one of Vincent, seated before his easel on a rush-bottomed chair painting sunflowers. In *The Painter of Sunflowers* (fig. 33), Gauguin portrayed Vincent with his hand poised, contemplating his next stroke on the canvas while studying his subject through half-closed eyes. Sunflowers were long out of season by this time, but in his composition, Gauguin fused a known reality with an invented fiction. From an elevated vantage point, the painter forced Vincent

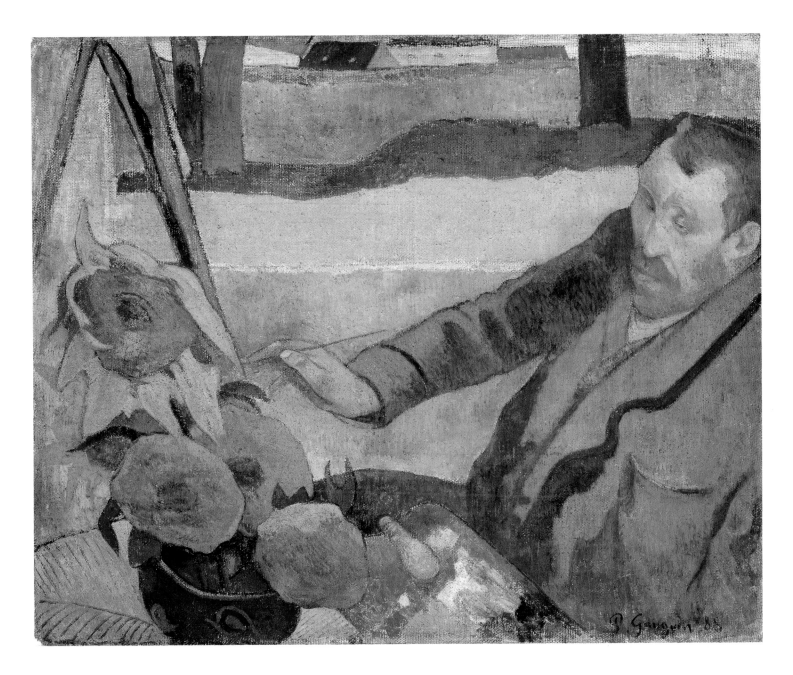

into an uncomfortable, compressed space, distorting his sitter's face and asserting, symbolically, his own privileged position in their relationship.

Later in December, Gauguin composed another response to his time with Vincent in a work he titled *Arlésiennes (Mistral)* (fig. 34). On a curving walkway, Gauguin portrayed two pairs of local women, the first clutching their shawls close to their faces to protect themselves against the raw north wind. The grouping of the figures recalls the mute and mysterious women he depicted in his first painting of Arles's Roman cemetery, *Les Alyscamps* (fig. 25); the somber mood of stifled grief gives the gestures of the figures in the later composition the emphasis of ritual. At mid-month Vincent and Gauguin made a brief trip to Montpellier; the heated discussions prompted by the art collection in this city's Musée Fabre only exacerbated the friction between them.

Gauguin's account of the events of 23 December would shift over the years to fit his needs. In a letter to Bernard he wrote from Paris a few days later, he stated that Vincent had become increasingly agitated, even preaching as if he

Fig. 33
Gauguin
The Painter of Sunflowers
Arles, c. 1 December 1888
(Amsterdam only)

Fig. 34
Gauguin
Arlésiennes (Mistral)
Arles, mid-December 1888

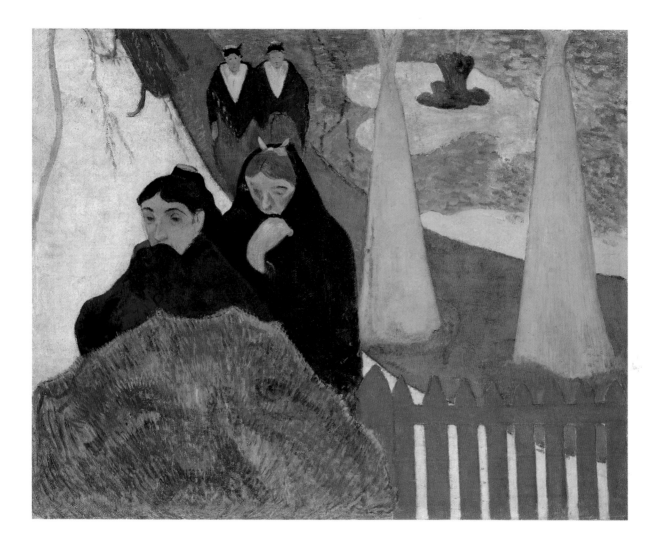

were Christ. Their conversations had taken an unsettling turn, touching upon sainthood, madness, and murder. While they were out walking that evening, Vincent confronted Gauguin, asking him directly if he intended to leave. When he answered yes, Vincent fled from him. Feeling uneasy about his companion's disturbed state, Gauguin spent the night in a hotel.

The following morning, Gauguin returned to the Yellow House to find a crowd gathered there and the house spattered with blood. He was taken into custody by the police, and during questioning was told that, after their confrontation, Vincent returned home, where he lacerated his left ear with a razor. He then went to a brothel, and was eventually taken to the hospital. Gauguin

dispatched a telegram to Theo, who rushed to his brother's side on Christmas morning. At the hospital, Theo found Vincent alternating between calm and agitation. Seeing that his brother's physical condition was stable, Theo returned to Paris on the late-night train. Gauguin did not visit his friend in the hospital. He rode the train with Theo and never saw Vincent again.

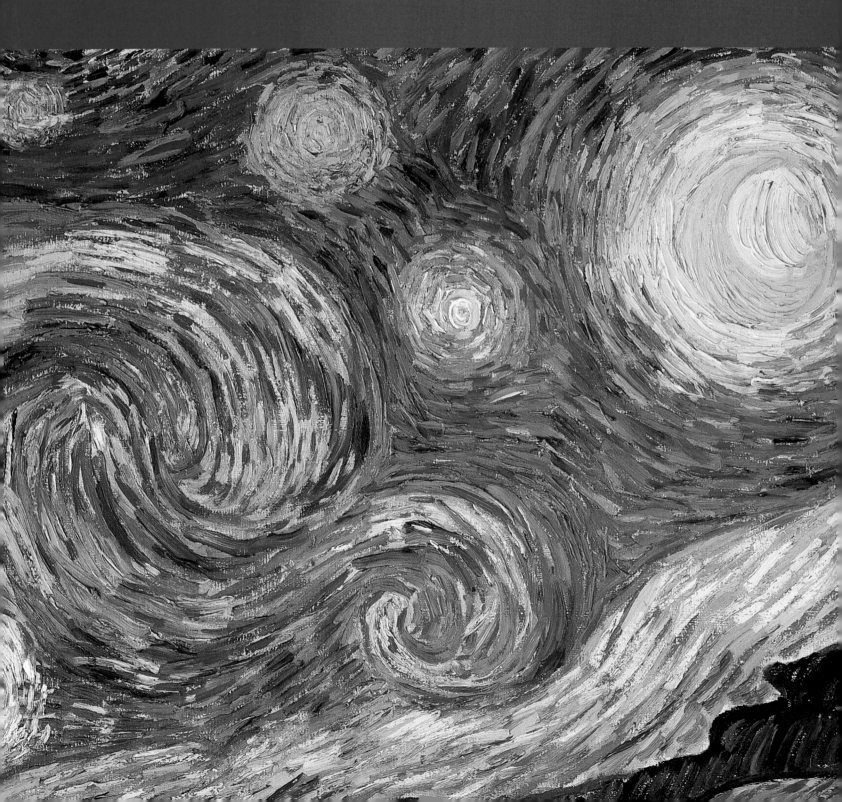

Van Gogh
The Starry Night
Fig. 38 (detail)

CHAPTER FIVE # AFTERMATH

Early in January 1889, Vincent wrote to his brother to reassure him that his incident of "over-excitement" had passed and that he was on the road to recovery. He also revealed that Gauguin was never far from his thoughts and asked Theo to relay his concern to his former housemate. On 4 January, Joseph Roulin escorted Vincent from the hospital to place Lamartine for a brief outing, and Vincent took the opportunity to write a letter asking Gauguin to refrain "from speaking ill of our poor little Yellow House." Vincent knew that he had destroyed the future of the Yellow House as an artists' refuge, for, as he admitted to Theo, "Everyone will be afraid of me." He was also deeply hurt that Gauguin had left Arles without a word and ignored his pleas to visit him in the hospital. Released on 7 January, Vincent returned to the Yellow House alone.

He immediately set to work, as if to prove to himself as well as to others that he was not insane. He executed a still life (1889; Otterlo, Kröller-Müller Museum) with onions and a lit candle—symbols from his chair portraits—and two self-portraits, showing him bundled in a winter coat and a large fur hat, that do not disguise his heavily bandaged ear (1889; London, Courtauld Institute, and private collection). He then turned his efforts to a nearly finished portrait that he had begun in December of the postman's wife, Augustine, seated in Gauguin's armchair and holding a rope that was attached to her infant's unseen cradle (fig. 35). Vincent now described the work as a "lullaby in colors," and suggested that the painting might accompany sailors on a fishing boat, to rouse their memories from infancy of being safely rocked to sleep. He called the portrait *La Berceuse* (meaning lullaby), signifying both the woman and her comforting song, and he proposed to place it between two of his sunflower paintings, like a modern altarpiece.

The envisioned ensemble of *La Berceuse* between *Sunflowers* allowed Vincent to resume his dialogue with Gauguin on his own terms. In Gauguin's absence, he freely recalled and selectively interpreted their discussions without any danger of disagreement. He reshaped the memory of their relationship into an ideal communion, such as those he had imagined for himself with Millet and Monticelli. In this way, *La Berceuse* can be seen as Vincent's response to

Fig. 36
Van Gogh
Sunflowers
Arles, late January 1889

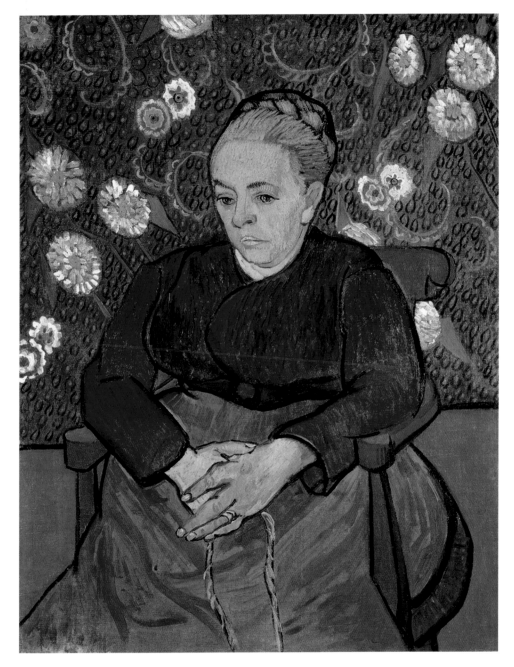

Fig. 35
Van Gogh
Madame Roulin Rocking the Cradle (La Berceuse)
Arles, C. 22 FEBRUARY 1889

Gauguin's portrayal of the same model, which had been left behind in the studio when he departed. And in response to a request Gauguin made to Vincent in mid-January for the yellow-on-yellow *Sunflowers* that Vincent had painted the previous August, he made copies of his signature subject (see fig. 36), which he associated with his relationship to Gauguin.

Upon completing *La Berceuse*, Vincent undertook more versions, including one to send to Holland, one for the Roulins, and, most importantly, one for Gauguin. He claimed the act of repetition calmed him, but the process of painting these images—so closely connected in his mind to his friend—proved dangerously stimulating. In early February, Vincent suffered paranoid delusions. He was hospitalized for a short time, and although he was able to return to the Yellow House to work during the day, his neighbors soon circulated a petition of protest. Upon police order, Vincent was confined to the hospital, and on 3 March the Yellow House was closed. After weeks of discussion, Vincent agreed to move to the small, private asylum Saint-Paul-de-Mausole in Saint-Rémy-de-Provence, fifteen miles northeast of Arles.

Early in May, Vincent checked into the asylum, where doctors diagnosed his condition as epilepsy. They wisely

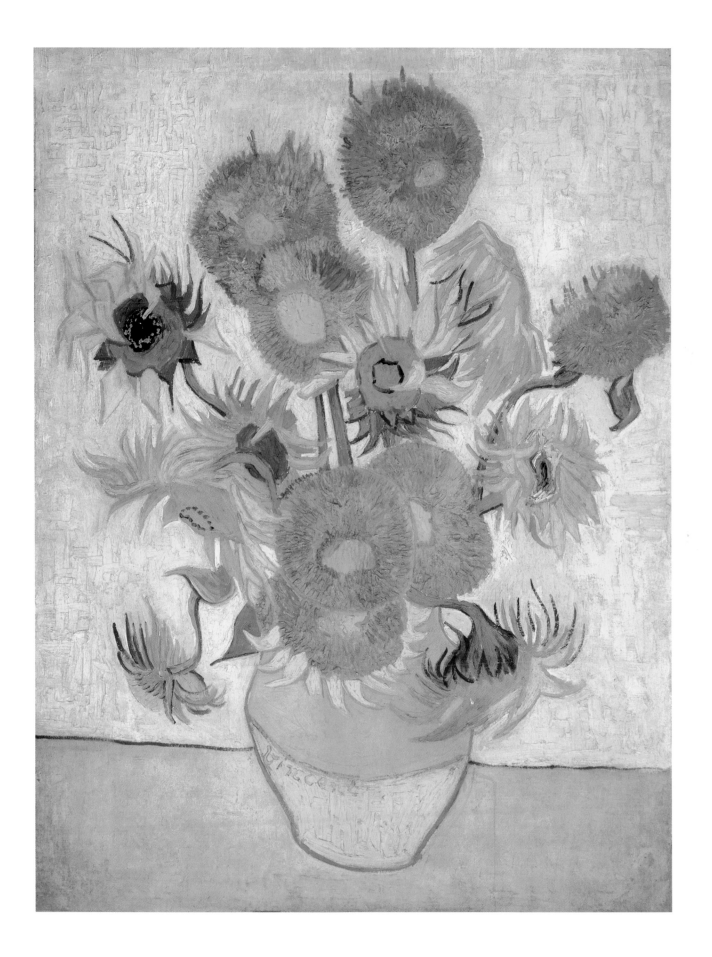

Fig. 37
Gauguin
Self-Portrait Jug
Paris, c. 1 February 1889

allowed him to paint, which bolstered his sense of purpose. He chose to depict the olive groves (see fig. 47) and cypress trees (see fig. 39) that lay beyond the confines of the asylum, and in these compositions the natural world appears charged with almost supernatural energy. In mid-June he painted the night sky, a subject he had first attempted in *The Starry Night over the Rhone* (fig. 19). In his new *Starry Night* (fig. 38), Vincent portrayed the forceful rhythms of a divinized nature in an unfurling firmament and haloed stars that pulsate majestically in concert with the writhing contours of the trees and mountains. Although based in observed reality, the composition became an invention upon nature, Vincent's vision of Saint-Rémy, in which he freely deployed Gauguin's ideas about style to achieve an expressive result that was purely his own. Vincent left the asylum in July for a brief visit to Arles, but upon his return, while painting outside, he suffered a profound seizure that prevented him from working again until September.

Like Vincent, Gauguin felt the strong presence of his absent companion. In Paris he alone had to account for the demise of their partnership, and his story reflected his desire to preserve his own reputation. He continually modified his point of view, sometimes defending Vincent's sanity, while other times con-

fessing that he had feared for his life and that, in their final encounter, Vincent had brandished a razor at him before retreating to the Yellow House to maim himself. In the aftermath of Vincent's February breakdown, Gauguin revived his self-identification with Jean Valjean, the tormented protagonist of Hugo's *Les Misérables,* in a stoneware *Self-Portrait Jug* (fig. 37). With eyes closed and blood streaming from the neck, the piece resembles a severed head, a grisly image of the type that had come to signify mysticism and artistic martyrdom among a group of young writers and artists known as the Symbolists. But, as the lack of ears

implies, Vincent's self-mutilation still haunted him. The young protagonists of the Symbolist movement had in fact begun to visit Theo's gallery in Montmartre, where they admired the recent works from Arles by both Vincent and Gauguin. Sensing the emphasis on the spiritual within this new audience for his work, Gauguin now cloaked his theories in the metaphors of religious purpose that Vincent had developed through his extensive reading and reflections. The ideas took root among some of the artists, who adopted the name "Nabis," a Hebrew word for prophets. They regarded themselves as an artistic frater-

Fig. 38
Van Gogh
The Starry Night
Saint-Rémy, 17/18 June 1889

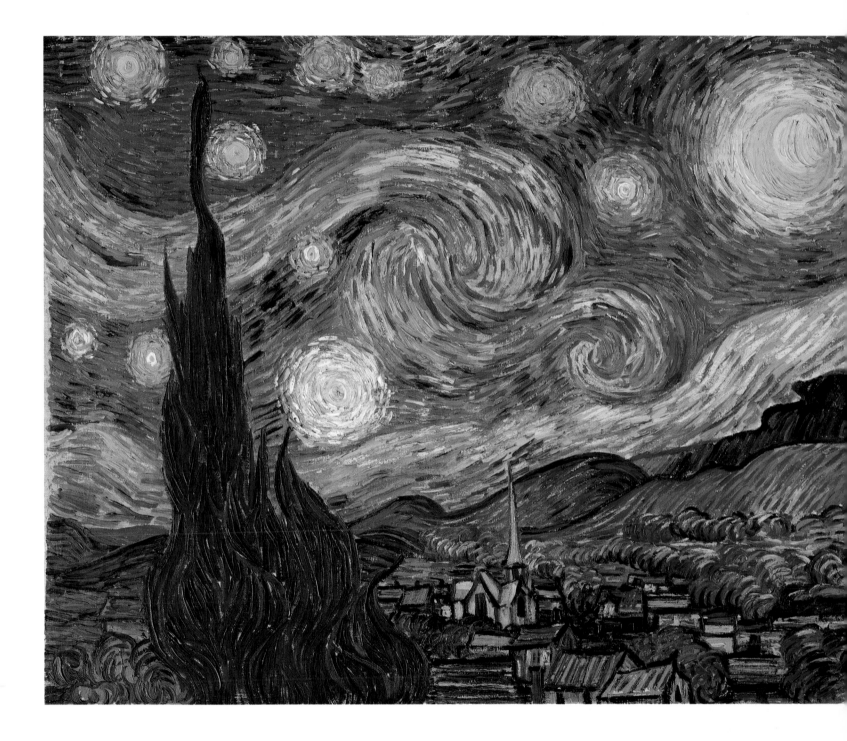

Fig. 39
Van Gogh
Cypresses
Saint-Rémy, 25 June 1889

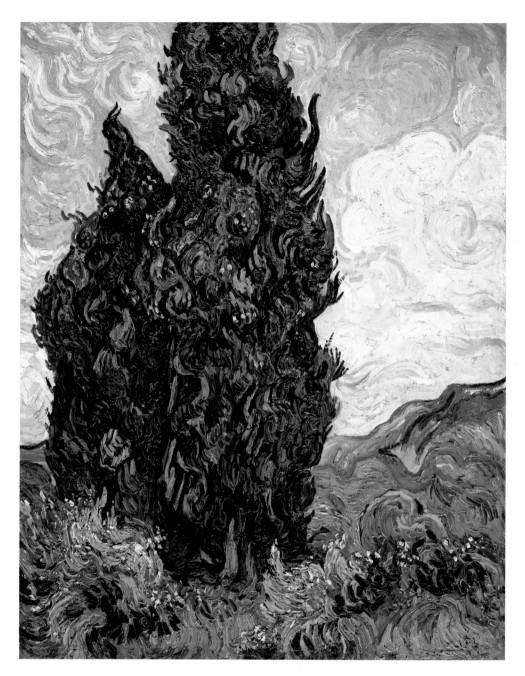

nity and increasingly as "disciples" of "the Nabi Gauguin."

Restless in his desire for new experiences in new surroundings, Gauguin left Paris in June, seeking to rekindle the inspiration he had found in Brittany. He seemed even more determined to assume the identity that Vincent had assigned him: "the man who comes from afar and who will go far." His new work in Pont-Aven echoes all that he had shared with Vincent in Arles. In *Christ in the Garden of Olives* (fig. 40), he took up a subject that had frustrated Vincent: Christ at Gethsemane confronting his doubts about his final sacrifice. Gauguin succeeded where Vincent had failed, but in a strange gesture he merged their two identities. He gave the figure of Christ his own aquiline features, while rendering the hair and beard bright red—like Vincent's—instead of using his own brunet coloring.

Gauguin stayed in Pont-Aven for one month and then in July moved to the more remote village of Le Pouldu, on the Atlantic coast. He was joined by Meyer de Haan, a young, red-haired Dutch painter who willingly played the role of disciple and also took care of their expenses. Like Vincent in Saint-Rémy, Gauguin pursued a new approach to landscape, as seen in the stylized forms, arbitrary placements, simplified color fields, and taut linear description of *The Red Cow* (fig. 41). But his relationship to nature was poles apart from that of his former housemate. While Vincent accorded the natural world primacy by exaggerating its vitality, Gauguin subordinated it to his belief that the artist should "extract from nature while dreaming before it," interpreting it and deepening its meaning through freely invented design and chromatics. Later that summer, Gauguin painted subjects inspired by the distinctive carved crucifixes (*calvaires*) that graced the public squares, crossroads, and churchyards of Brittany. In *Yellow Christ* (fig. 42), he reasserted the

Fig. 40
Gauguin
Christ in the Garden of Olives
Pont-Aven, June 1889

59

Fig. 41
Gauguin
The Red Cow
Le Pouldu, summer 1889

Fig. 42
Gauguin
Yellow Christ
Pont-Aven or Le Pouldu, September 1889

stressing that chromatic expression was far more important than descriptive accuracy. Emphasizing yellow in such a way, Gauguin linked his work to Vincent's signature color, the one he favored for *Sunflowers*—his symbol for devotion—and for *The Sower*—his emblem for the artist's mission and the eternal cycle of life and death.

Over the summer, as Vincent regained strength, his desire for companionship revived. On 6 September, now recovered and able to paint, he wrote to Theo, "I tell myself that Gauguin and I will perhaps work together again." While Vincent sought reassurance about his physical and psychic stability in his wish to be reunited with Gauguin, he drew consolation from the subjects he painted, a self-portrait that hides his damaged ear (fig. 43) and a reprise of the tender view of his bedroom in the Yellow House (fig. 44) that he had painted a year before in anticipation of Gauguin's arrival (1888; Amsterdam, Van Gogh Museum). Vincent's longing for a working partnership intensified as the year drew to a close, prompted to some extent by Gauguin's report of a project he was carrying out in Le Pouldu with de Haan: the decoration of the dining-room walls of the inn Buvette de la Plage. Embedded in the program of imagery was a response to the Yellow House and Vincent's vision

spirituality that he had first explored in *Vision of the Sermon*, using color to create a mood of transcendence. The brilliant and solemn *Yellow Christ* features a specific crucifix, a polychromed piece in a chapel in Tremâlo, near Pont-Aven. Gauguin explained his refusal to render the actual setting for the crucifix by

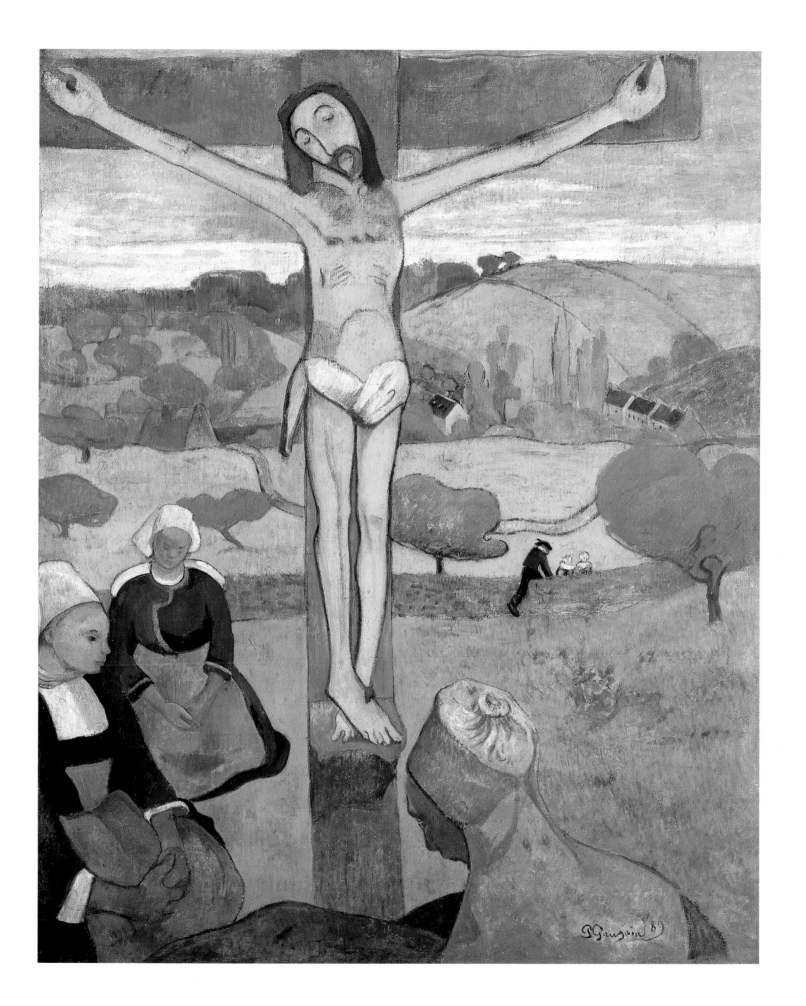

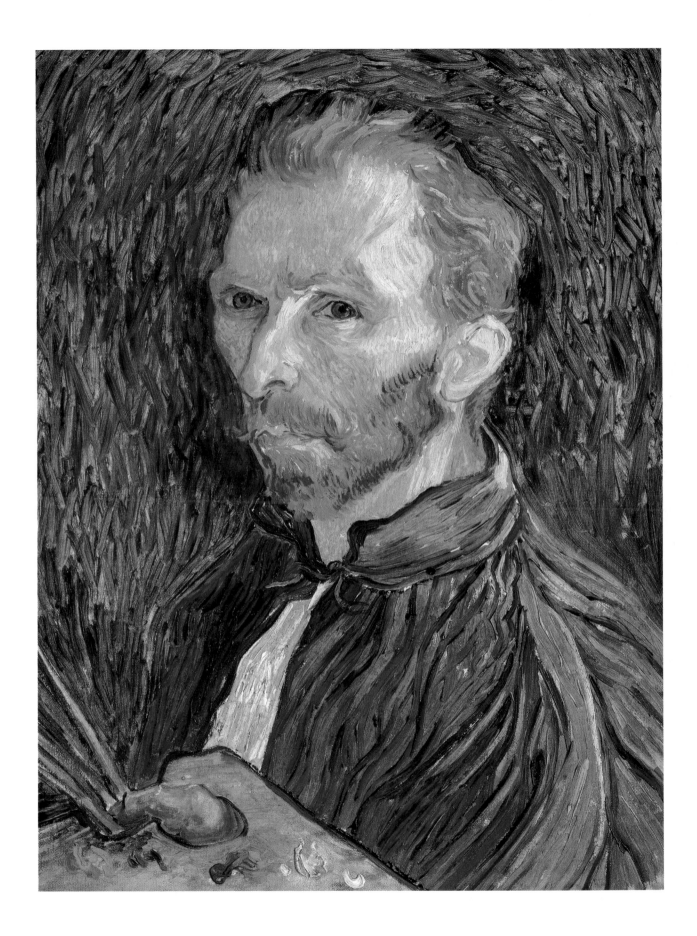

Fig. 43
Van Gogh
Self-Portrait with Palette
Saint-Rémy, c. 1 September 1889

Fig. 44
Van Gogh
The Bedroom
Saint-Rémy, c. 5 September 1889

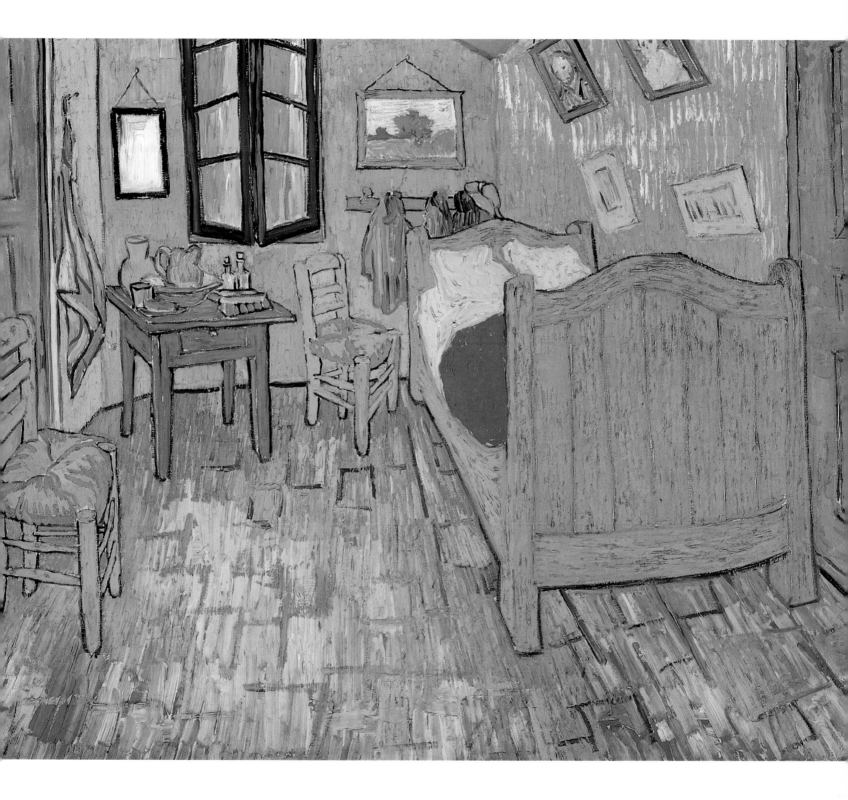

Fig. 45
Gauguin
Bonjour, Monsieur Gauguin
Le Pouldu, November 1889

Fig. 46
Gauguin
Female Nude with Sunflowers
(known as *Caribbean Woman*)
Le Pouldu, November 1889

64

of a Studio of the South. The scheme featured two portraits by Gauguin—one of himself and one of the red-haired de Haan. By splitting the chromatic field of the background in his self-portrait—half blood-red and half brilliant yellow— Gauguin used color association to allude to his lost partnership with Vincent.

A second self-portrait in the ensemble situated Gauguin in the present, rather than the past. In *Bonjour, Monsieur Gauguin* (fig. 45), a title the artist adapted from a self-portrait by Gustave Courbet that he and Vincent had seen at the Musée Fabre in Montpellier, Gauguin presented himself as a wanderer standing behind a closed gate. Dressed for travel, he holds a walking staff, a traditional attribute of the pilgrim. The bleak, autumnal landscape and menacing sky portend a dangerous voyage. The direction of this journey is indicated by another painting in the inn's decoration. *Female Nude with Sunflowers* (known as *Caribbean Woman*) (fig. 46) evokes both Gauguin's history and Yellow House iconography. The dark-skinned figure and the large blooms recall Gauguin's first exchange of paintings with Vincent: his Martinique image of women for Vincent's cut sunflowers. But the decorative abstraction of his composition and the ritualized gestures of the figure look forward rather than back. In *Female Nude with Sunflowers*, Gauguin transplanted the

vision of the Studio of the South to the tropics.

Early in January 1890, Vincent contemplated leaving Saint-Rémy and wrote to Gauguin to see if he and de Haan would welcome him in Le Pouldu. Gauguin sidestepped the inquiry, explaining that life was difficult in the rugged coastal village and that his own departure was imminent. He planned to travel to Tonkin (now part of Vietnam), where he hoped to secure a comfortable posting through the colonial department. Vincent then channeled his energies into a series of paintings based on the drawing of Madame Ginoux that Gauguin had left in the studio in Arles (fig. 28). Once again his immersion in a theme related to his friendship with Gauguin had an adverse effect. On 22 February, Vincent traveled to Arles to present Madame Ginoux with one of his paintings of her, and while there suffered a breakdown that proved decisive. He was disabled for two months, and when he recovered he agreed to Theo's suggestion that he move to Auvers, a village to the north of Paris, where he could live and work under the watchful eye of a physician named Paul Gachet.

Vincent left Provence on 17 May, stopping in Paris for a brief visit with his brother, recently married and a father, before he settled in Auvers. By early June, he reported to Theo that he and Doctor Gachet had become great friends, and that he regarded him as another brother. Later that month, painting in a panoramic format, he revived his enduring image of companionship, two lovers strolling in a forest. But the setting for

In the Forest (fig. 48) offers no solace. The figures seem trapped among staggered tree trunks; with no path in view, the composition denies the pair any physical or imaginative escape. Through the late spring and early summer, Vincent depicted vast stretches of wheat under troubled skies that testify to his loneliness, and on 17 July he spoke of being almost too calm, a mood that fostered his painting of vistas as boundless as the

sea. Ten days later, he shot himself. On 29 July 1890, with Theo at his side, Vincent died from his injuries. The funeral took place in Auvers the following day. Gauguin did not attend, and confided to Bernard, who did make the journey, that he believed that the suicide was inevitable; Vincent was better off out of his misery.

Gauguin
Day of the God (Mahana no atua)
Fig. 50 (detail)

THE JOURNEY ALONE

In the year following Vincent's suicide, Gauguin realized that in death his late friend was as great a force to be reckoned with as he had been in life. Vincent's talent was beginning to be recognized. This process was enhanced by the legendary quality that his life began assuming as details of his turbulent existence became known. Gauguin responded by devoting his full attention to his plans to move to the tropics. As he literally set out on the journey to fulfill the mythic identity Vincent had been so central in formulating for him, he would increasingly encounter reminders that the fame and acknowledgment he was seeking had been granted posthumously to his friend.

Unable to find a post in Tonkin, Gauguin considered moving to Madagascar, but by September 1891 he dismissed the island off the east coast of Africa as too close to civilization. He set his sights instead on Tahiti, convinced that in "primitive" surroundings he could nurture the "savage" aspects of his art. He was also well aware that painting in a distant land would lend his works an exotic air when they were sent to Paris for exhibition. To fund his journey,

Gauguin auctioned his work in February 1891 and made a successful application for government sponsorship of his artistic mission to the French colony. In April, after a brief visit with his family in Copenhagen, he set sail for Tahiti from Marseilles.

Gauguin arrived in the capital, Papeete, in June, docking at just the moment when Tahiti's last native ruler, King Pomare V, died. Although the funerary rituals reflected long-standing traditions, Gauguin took note of the pervasive influence of Europe. He complained to Mette that "Tahiti is becoming completely French. Little by little, all the ancient ways of doing things will disappear." During his first months, Gauguin approached his new environment with an eye to documentation, making a careful study of the region and its inhabitants. After several months, he found he could balance his heightened attention to objective detail with his characteristic decorative sensibility, as demonstrated in *The Hibiscus Tree (Te burao)* (fig. 49). But he also sought a more intensely authentic experience; through his liaisons with local women and reading about Tahiti's

Fig. 49
Gauguin
The Hibiscus Tree (Te burao)
Mataiea, 1892

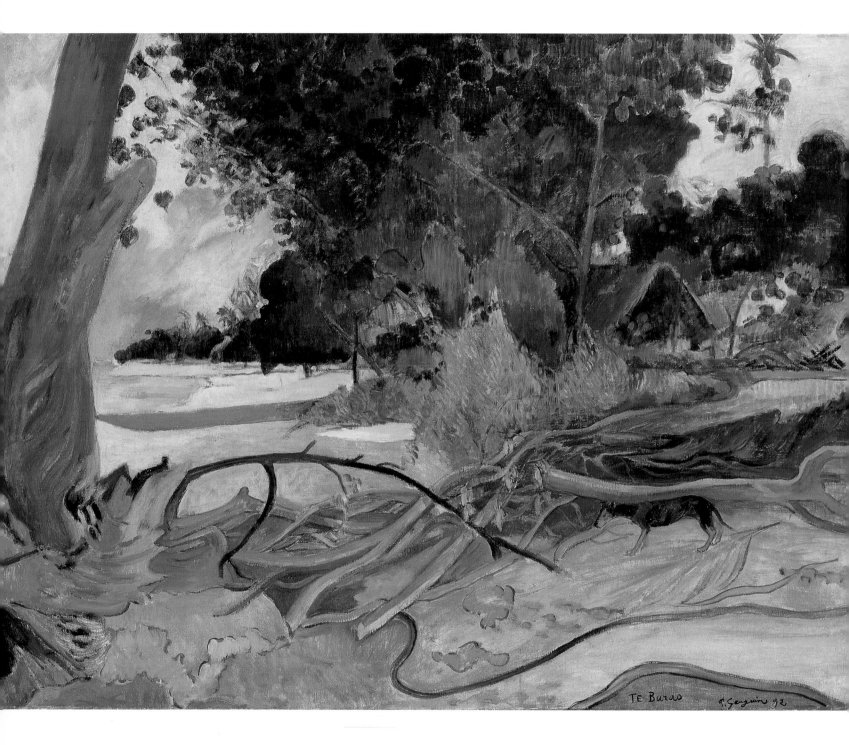

Fig. 50
Gauguin
Day of the God (Mahana no atua)
Paris, 1894

cultural history, he forged a bond with his new surroundings. As he moved around the island, Gauguin found that little remained of its pre-colonial past; he relied on his own power of mythic invention to add mystery to the subjects he selected for his art. By March 1893,

Gauguin had completed more than sixty paintings, and although he had considered leaving Tahiti after only nine months, he remained until June of that year, when he received support from the French government for his return home.

Gauguin was disappointed by the

mixed reception of his work in Paris. In response he exaggerated his "savage" persona through eccentric behavior, wearing outlandish clothing, adopting a pet monkey, and flaunting his affair with a thirteen-year-old mistress from Ceylon. Signaling his connection to the increas-

ingly famous Vincent, he painted his rented studio on rue Vercingétorix a brilliant, sun-drenched yellow and covered the walls with his new canvases, along with his small collection of the deceased artist's paintings. He hosted weekly gatherings for painters, writers, and musicians and read to his guests the memoir he was writing. The evocative language of the text, which he called *Noa Noa* (Tahitian for "perfume"), describes his immersion in a "primitive" culture as a journey of artistic and spiritual transformation. In a parallel endeavor, Gauguin painted a brilliant evocation of Polynesian cosmology. He fabricated *Day of the God (Mahana no atua)* (fig. 50) from memory, documents, and imagination, but the primacy of his extraordinary journey gives this work, and others like it, a unique authority. The ethnographic details of his inventive account of his tropical adventure went unchallenged; Tahiti provided a blank canvas on which he was free to depict his exotic fantasies.

In April 1894, Gauguin moved back to Brittany, but after his experiences in the South Seas, he found that the rugged region no longer had the same appeal for him. One year later—bitter and defiant—he returned to Tahiti. During his absence, electric lights had been installed in Papeete. To escape what he considered the spreading contamination of European progress, Gauguin announced plans to travel to the Marquesas, a remote group of islands 750 miles northeast of Tahiti. Hampered by illness and dwindling finances, Gauguin settled instead in Punaauia, a village fifteen miles south of the capital. By 1896 he described himself as without hope, feeling more like a martyr than an adventurer.

But Gauguin endured, and always attentive to news from Paris, he monitored the posthumous rise of Vincent's reputation that brought his friend's paintings increased value as well as respect. His regret was burnished with nostalgia for his lost life, and in 1898 he asked a friend in France to send him seeds for his garden to give him a bit of pleasure in the absence of hope. He specifically requested a variety of sunflowers; the floral still lifes he painted in 1901 feature Vincent's signature flower. Always finding the richest source of ideas in his own imagination, Gauguin drew upon his memory of Arles, painting a bouquet of sunflowers in a plaited basket positioned on the seat of an armchair (fig. 51). A window frames the face of a passing Tahitian woman; the elements of his past appear like shrines in his present.

A radiant floral form that seems to have detached itself from the bouquet rises above the armchair. The dull-bronze eye shape has the intensity and focus of deep meditation. Although dead more than decade and buried half a world way, Vincent's presence haunted Gauguin's studio.

In September 1901, Gauguin finally moved to the Marquesas. Although he sought rejuvenation, on the island of Hiva Oa he felt exiled. Lonely and homesick, he wrote to a friend in Paris in 1902 that he longed to return to France. His friend discouraged him, explaining that at this point in his life his legend drew power from his absence, making it seem as if the works he sent to Paris were appearing out of a mysterious void. Gauguin's continuing poor health and lack of funds confined him to Hiva Oa, where he died on 8 May 1903. The rootlessness that had propelled him to seek new surroundings had depleted him and left him alone and unsatisfied in the end. He may have failed in his own quest, but in his pursuit of a Studio of the Tropics, Gauguin fulfilled the mission Vincent defined for him in Arles; the journey that defined his mythic reputation was launched from the Studio of the South.

Fig. 51
Gauguin
Sunflowers on an Armchair
Punaauia, 1901

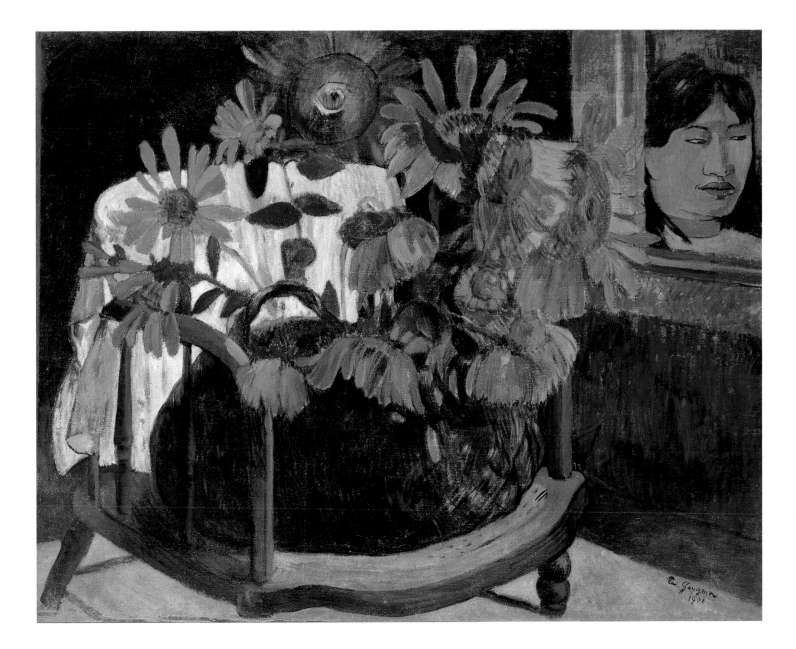

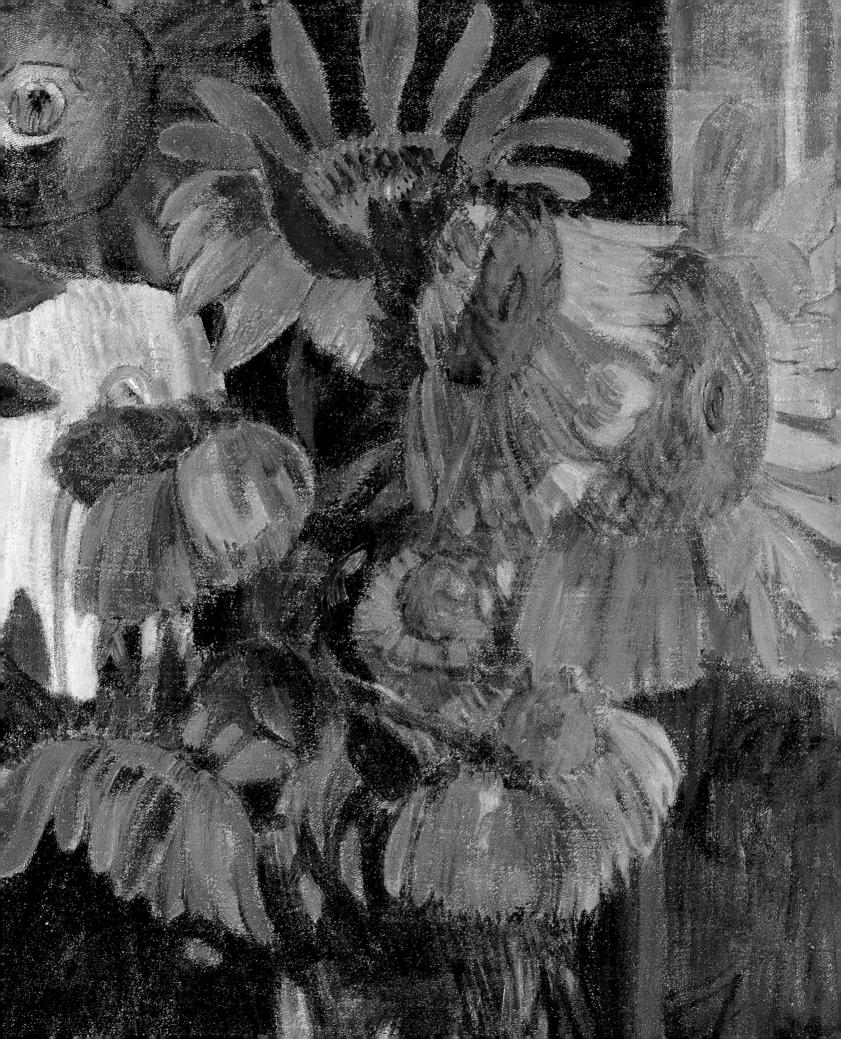

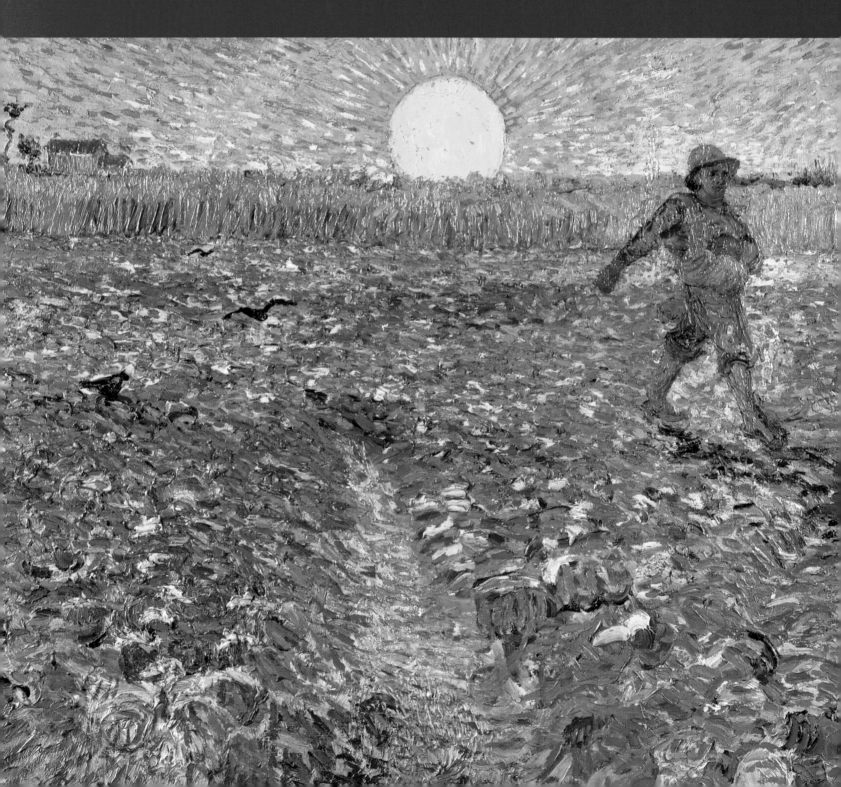

Van Gogh
The Sower
Fig. 16 (detail)

LIST OF ILLUSTRATIONS

NOTE TO THE READER

The dates given here reflect research undertaken for this exhibition and may vary from dates published elsewhere; they are based primarily on the artists' correspondence, in combination with technical examination. In addition to self-explanatory designations, the following illustrate conventions used: c. 4 November 1888: executed within roughly a week of 4 November 1888; 4–11 November 1888: begun on 4 November and completed on 11 November 1888; 4/11 November 1888: executed sometime between 4 and 11 November 1888. Dimensions are given in centimeters, height preceding width.

Fig. 1
Photograph of Vincent van Gogh at the age of eighteen.

Fig. 2
Photograph of Paul Gauguin and his wife, Mette, Copenhagen, 1885.

Fig. 3
Vincent van Gogh (Dutch; 1853–1890)
Self-Portrait with Dark Felt Hat at the Easel
Paris, spring 1886
Oil on canvas; 46.5 x 38.5 cm
Van Gogh Museum, Amsterdam (Vincent van Gogh Foundation), S160 V/1962

Fig. 4
Paul Gauguin (French; 1848–1903)
Self-Portrait at the Easel
Copenhagen, c. 1 May 1885
Oil on canvas; 65.2 x 54.3 cm
Kimbell Art Museum, Fort Worth, Texas, 1997.03

Fig. 5
Van Gogh
Still Life with Bible and Zola's "Joie de vivre"
Nuenen, October 1885
Oil on canvas; 65 x 78 cm
Van Gogh Museum, Amsterdam (Vincent van Gogh Foundation), S08 V/1962

Fig. 6
Gauguin
The Faun
Paris, winter 1886
Unglazed stoneware with touches of gilding; h. 47 cm
The Art Institute of Chicago, estate of Suzette Morton Davidson; Major Acquisitions Centennial Endowment, 1997.88

Fig. 7
Gauguin
Breton Shepherdess
Pont-Aven, summer 1886
Oil on canvas; 60.4 x 73.3 cm
Laing Art Gallery, Newcastle upon Tyne (Tyne and Wear Museums), C643

Fig. 8
Gauguin
Still Life with Profile of Charles Laval
Paris, late 1886
Oil on canvas; 46 x 38 cm
Indianapolis Museum of Art, Samuel Josefowitz Collection of the School of Pont-Aven, through the generosity of the Lilly Endowment Inc., the Josefowitz Family, Mr. and Mrs. James M. Cornelius, Mr. and Mrs. Leonard J. Betley, Lori and Dan Efroymson, and other Friends of the Museum, 1998.167

Fig. 9
Gauguin
Conversation (Tropics)
Martinique, summer 1887
Oil on canvas; 61.5 x 76 cm
Private collection

Fig. 10
Van Gogh
Fishing in Spring, the Pont de Clichy (Asnières)
Paris, spring 1887
Oil on canvas; 49 x 58 cm
The Art Institute of Chicago, gift of Charles Deering McCormick, Brooks McCormick, and Roger McCormick, 1965.1169

Fig. 11
Van Gogh
Self-Portrait
Paris, spring 1887
Oil on artist's board, mounted on cradled wood panel; 41 x 32.5 cm
The Art Institute of Chicago, Joseph Winterbotham Collection, 1954.326

Fig. 12
Van Gogh
A Pair of Boots
Paris, summer 1887
Oil on canvas; 33 x 40.9 cm
The Baltimore Museum of Art, The Cone Collection, formed by Dr. Claribel Cone and Miss Etta Cone of Baltimore, Maryland, 1950.302

Fig. 13
Van Gogh
Two Sunflowers
Paris, summer 1887
Oil on canvas; 43.2 x 61 cm
The Metropolitan Museum of Art, New York, Rogers Fund, 1949, 49.41

Fig. 14
Van Gogh
Parisian Novels
Paris, late 1887
Oil on canvas; 73 x 93 cm
Private collection

Fig. 15
Van Gogh
Pear Tree in Blossom
Arles, April 1888
Oil on canvas; 73 x 46 cm
Van Gogh Museum, Amsterdam
(Vincent van Gogh Foundation),
S39 V/1962

Fig. 16
Van Gogh
The Sower
Arles, mid-June 1888
Oil on canvas; 64 x 80.5 cm
Kröller-Müller Museum, Otterlo,
The Netherlands, 303-18

Fig. 17
Gauguin
Breton Girls Dancing
Pont-Aven, June 1888
Oil on canvas; 73 x 92.7 cm
National Gallery of Art,
Washington, D.C., Collection of
Mr. and Mrs. Paul Mellon, 1983.1.19

Fig. 18
Van Gogh
Sunflowers
Arles, c. 1 December 1888
Oil on jute; 100 x 76 cm
Seiji Togo Memorial Yasuda Kasai
Museum of Art, Tokyo, LO-175

Fig. 19
Van Gogh
The Starry Night over the Rhone
Arles, 28 September 1888
Oil on canvas; 72.5 x 92 cm
Musée d'Orsay, Paris, life-interest
gift of M. and Mme Robert Kahn-
Sriberen in memory of M. and
Mme Fernand Moch, 1975, entered
the collection in 1995, R.F. 1975-19

Fig. 20
Van Gogh
The Yellow House
Arles, 28 September 1888
Oil on canvas; 76 x 94 cm
Van Gogh Museum, Amsterdam
(Vincent van Gogh Foundation),
S32 V/1962

Fig. 21
Gauguin
Vision of the Sermon
Pont-Aven, mid-August–mid-
September 1888
Oil on canvas; 73 x 92 cm
National Gallery of Scotland,
Edinburgh, NG1643

Fig. 22
Van Gogh
*Self-Portrait Dedicated to Paul
Gauguin (Bonze)*
Arles, c. 16 September 1888
Oil on canvas; 61 x 50 cm
Fogg Art Museum, Harvard
University Art Museums, bequest
from the Collection of Maurice
Wertheim, Class of 1906, 1951.65

Fig. 23
Gauguin
*Self-Portrait Dedicated to Vincent van
Gogh (Les Misérables)*
Pont-Aven, late September 1888
Oil on canvas; 45 x 55 cm
Van Gogh Museum, Amsterdam
(Vincent van Gogh Foundation),
S224 V/1962

Fig. 24
Van Gogh
Allée des Tombeaux (Les Alyscamps)
Arles, c. 29 October 1888
Oil on canvas; 89 x 72 cm
Private collection

Fig. 25
Gauguin
*Les Alyscamps (The Three Graces at the
Temple of Venus)*
Arles, c. 29 October 1888
Oil on canvas; 92 x 73 cm
Musée d'Orsay, Paris, bequeathed
by the comtesse Vitali, in memory
of her brother the vicomte de
Cholet, 1923, R.F. 1938-47

Fig. 26
Van Gogh
The Arlésienne (Madame Ginoux)
Arles, c. 4 November 1888
Oil on jute; 93 x 74 cm
Musée d'Orsay, Paris; life-interest
gift of Mme R. de Goldschmidt-
Rothschild, announced on 25
August 1944, day of the Liberation
of Paris, and entered the collection
in 1974, R.F. 1952-6

Fig. 27
Gauguin
Madame Ginoux (study for *Night
Café*)
Arles, c. 4 November 1888
White and colored chalks and char-
coal on wove paper; 56.1 x 49.2 cm
Fine Arts Museums of San
Francisco, memorial gift from Dr.
T. Edward and Tullah Hanley,
Bradford, Pennsylvania, 69.30.78

Fig. 28
Gauguin
Night Café
Arles, 4–12 November 1888
Oil on jute; 72 x 92 cm
The State Pushkin Museum of Fine
Arts, Moscow, 3367

Fig. 29
Gauguin
Human Miseries (*Grape Harvest* or
Poverty)
Arles, 4–11 November 1888
Oil on jute; 73 x 93 cm
Ordrupgaard, Copenhagen, 223
WH

Fig. 30
Van Gogh
Van Gogh's Chair
Arles, c. 20 November 1888
Oil on jute; 93 x 73.5 cm
The National Gallery, London,
NG3862

Fig. 31
Van Gogh
Gauguin's Chair
Arles, c. 20 November 1888
Oil on jute; 90.5 x 72 cm
Van Gogh Museum, Amsterdam
(Vincent van Gogh Foundation),
S48 V/1962

Fig. 32
Van Gogh
The Sower
Arles, c. 25 November 1888
Oil on canvas; 32 x 40 cm
Van Gogh Museum, Amsterdam
(Vincent van Gogh Foundation),
S29 V/1962

Fig. 33
Gauguin
The Painter of Sunflowers
Arles, c. 1 December 1888
Oil on jute
73 x 92 cm
Van Gogh Museum, Amsterdam
(Vincent van Gogh Foundation),
S225 V/1962
(Amsterdam only)

Fig. 34
Gauguin
Arlésiennes (*Mistral*)
Arles, mid-December 1888
Oil on jute; 73 x 92 cm
The Art Institute of Chicago, Mr.
and Mrs. Lewis Larned Coburn
Memorial Collection, 1934.391

Fig. 35
Van Gogh
*Madame Roulin Rocking the Cradle
(La Berceuse)*
Arles, c. 22 FEBRUARY 1889
Oil on canvas; 92 x 72.5 cm
Stedelijk Museum, Amsterdam

Fig. 36
Van Gogh
Sunflowers
Arles, late January 1889
Oil on canvas; 95 x 73 cm
Van Gogh Museum, Amsterdam
(Vincent van Gogh Foundation),
S31 V/1962

Fig. 37
Gauguin
Self-Portrait Jug
Paris, c. 1 February 1889
Glazed stoneware; h. 19.5 cm
Det Danske Kunstindustrimuseum,
Copenhagen, 962

Fig. 38
Van Gogh
The Starry Night
Saint-Rémy, 17/18 June 1889
Oil on canvas; 73.7 x 92.1 cm
The Museum of Modern Art, New
York, acquired through the Lillie P.
Bliss Bequest, 1941, 472.41

Fig. 39
Van Gogh
Cypresses
Saint-Rémy, 25 June 1889
Oil on canvas; 93.3 x 74 cm
The Metropolitan Museum of Art,
New York, Rogers Fund, 1949, 49.30

Fig. 40
Gauguin
Christ in the Garden of Olives
Pont-Aven, June 1889
Oil on canvas; 73 x 92 cm
Norton Museum of Art, West Palm
Beach, Florida, 46.5

Fig. 41
Gauguin
The Red Cow
Le Pouldu, summer 1889
Oil on canvas; 92 x 73 cm
Los Angeles County Museum of
Art, Mr. and Mrs. George Gard De
Sylva Collection, M.48.17.2

Fig. 42
Gauguin
Yellow Christ
Pont-Aven or Le Pouldu,
September 1889
Oil on canvas; 92 x 73 cm
Albright-Knox Art Gallery, Buffalo,
New York, General Purchase Funds,
1946, 46:4

Fig. 43
Van Gogh
Self-Portrait with Palette
Saint-Rémy, c. 1 September 1889
Oil on canvas; 57 x 43.5 cm
National Gallery of Art,
Washington, D.C., Collection of
Mr. and Mrs. Paul Mellon, 1988.74.5

Fig. 44
Van Gogh
The Bedroom
Saint-Rémy, c. 5 September 1889
Oil on canvas; 73.6 x 92.3 cm
The Art Institute of Chicago, Helen
Birch Bartlett Memorial Collection,
1926.417

Fig. 45
Gauguin
Bonjour, Monsieur Gauguin
Le Pouldu, November 1889
Oil on canvas laid down on wood;
75 x 55 cm
The Armand Hammer Collection,
UCLA Hammer Museum, Los
Angeles, AH.90.31

Fig. 46
Gauguin
Female Nude with Sunflowers (known
as *Caribbean Woman*)
Le Pouldu, November 1889
Oil on wood panel; 64 x 54 cm
Private collection

Fig. 47
Van Gogh
Olive Grove
Saint-Rémy, November 1889
Oil on canvas; 74 x 93 cm
The Minneapolis Institute of Arts,
The William Hood Dunwoody
Fund, 51.7

Fig. 48
Van Gogh
In the Forest
Auvers, c. 24 June 1890
Oil on canvas; 50 x 100 cm
Cincinnati Art Museum, bequest of
Mary E. Johnston, 1967.1430

Fig. 49
Gauguin
The Hibiscus Tree (Te burao)
Mataiea, 1892
Oil on canvas; 68 x 90.7 cm
The Art Institute of Chicago,
Joseph Winterbotham Collection,
1923.308

Fig. 50
Gauguin
Day of the God (Mahana no atua)
Paris, 1894
Oil on canvas; 68.3 x 91.5 cm
The Art Institute of Chicago, Helen
Birch Bartlett Memorial Collection,
1926.198

Fig. 51
Gauguin
Sunflowers on an Armchair
Punaauia, 1901
Oil on canvas; 73 x 92.3 cm
The State Hermitage Museum,
St. Petersburg, 6516

This book was published in conjunction with the exhibition "Van Gogh and Gauguin: The Studio of the South," organized by The Art Institute of Chicago and the Van Gogh Museum, Amsterdam.

Exhibition dates:
The Art Institute of Chicago,
 22 September 2001–13 January 2002
Van Gogh Museum, Amsterdam,
 9 February 2002–2 June 2002

The exhibition and the book that accompanies it were made possible through the generous support of Ameritech (Chicago) and ABN–AMRO (Amsterdam). Additional support was provided by: An indemnity from the Federal Council on the Arts and Humanities.

Essay by Debra N. Mancoff, based on research by Douglas W. Druick and Peter Kort Zegers, in collaboration with Britt Salvesen, for the exhibition catalogue *Van Gogh and Gauguin: The Studio of the South* (copublished by The Art Institute of Chicago and Thames and Hudson, New York/London, 2001)
Produced and edited by the Publications Department of The Art Institute of Chicago, Susan F. Rossen, Executive Director, with the assistance of Lisa Meyerowitz
Photo editor, Karen Altschul
Production supervised by Amanda W. Freymann

Designed and typeset by Joan Sommers Design, Chicago
Color separations by Professional Graphics Inc., Rockford, Ill.
Printed and bound by Amilcare Pizzi, S.p.A., Milan, Italy

ISBN 0-86559-195-4

All photographs of works of art in the collections of The Art Institute of Chicago illustrated in this publication are © The Art Institute of Chicago, photographed by Robert Hashimoto or Greg Williams, Department of Imaging, Alan B. Newman, Executive Director. All other photography credits are listed below, including material supplied by other institutions, agencies, or individual photographers. Wherever possible, photographs have been credited to the original photographers, regardless of the source of the photograph.

Figs. 1, 3, 5, 15, 20 (also front cover and frontispiece), 23 (also page 3), 31, 32, 33, 36 (also page 74 and back cover): Courtesy of Van Gogh Museum. Fig. 2: © Musée Départemental Maurice Denis "Le Prieuré," St.-Germain-en-Laye. Fig. 4 (also page 8): Photo by Michael Bodycomb. Figs. 13, 39: © The Metropolitan Museum of Art. Fig. 16 (also page 76): © Stichting Kröller-Müller Museum. Figs. 17, 43: © 2001 Board of Trustees, National Gallery of Art, Washington, D.C. Fig. 19: RMN/Art Resource, NY. Fig. 22 (also page 2): Photo by Katya Kallsen–© President and Fellows of Harvard College. Fig. 25 (also page 6): Scala/Art Resource, NY. Fig. 26: Photo by Erich Lessing/ Art Resource, NY. Fig. 29: Photo by Ole Woldbye–Ordrupgaard, Copenhagen. Fig. 30: © The National Gallery, London. Fig. 37: Photo by Ole Woldbye–The Danish Museum of Decorative Art, Copenhagen. Fig. 38 (also page 54): © 2001 The Museum of Modern Art, New York. Fig. 41 (also page 6): © 2001 Museum Associates/LACMA. Fig. 45: Photo by Robert Wedemeyer.

Front cover: Van Gogh, *The Yellow House* (detail), fig. 20
Page 2: Van Gogh, *Self-Portrait Dedicated to Paul Gauguin (Bonze)* (detail), fig. 22
Page 3: Gauguin, *Self-Portrait Dedicated to Vincent van Gogh (Les Misérables)* (detail), fig. 23
Page 6: (top) Van Gogh, *Olive Grove* (detail), fig. 47; (bottom) Gauguin, *The Red Cow* (detail), fig. 41
Page 74: Van Gogh, *Sunflowers* (detail), fig. 36
Page 75: Gauguin, *Sunflowers on an Armchair* (detail), fig. 51
Back cover: (left) Gauguin, *Female Nude with Sunflowers* (detail), fig. 46; (right) Van Gogh, *Sunflowers* (detail), fig. 36